HIDDEN
HISTORY
of
ALEXANDRIA,
D.C.

HIDDEN
HISTORY
of
ALEXANDRIA,
D.C.

Michael Lee Pope

THE
History
PRESS

Published by The History Press
Charleston, SC 29403
www.historypress.net

First published 2011

Manufactured in the United States

ISBN 978.1.60949.281.6

Library of Congress Cataloging-in-Publication Data

Pope, Michael Lee.
Hidden history of Alexandria, D.C. / Michael Lee Pope.
p. cm.
Includes bibliographical references.
ISBN 978-1-60949-281-6
1. Alexandria (Va.)--History--19th century. 2. Washington (D.C.)--History--19th century. I.
Title.
F234.A3P67 2011
975.5'296--dc23
2011031486

Notice: The information in this book is true and complete to the best of our knowledge. It is offered without guarantee on the part of the author or The History Press. The author and The History Press disclaim all liability in connection with the use of this book.

CONTENTS

Acknowledgements

This book would not have been possible without my lovely wife, Hope Nelson. She was patient during my time at the library, tolerant of my field trips to historic sites and helpful in whipping the copy into shape. Others I would like to thank include the following:

My parents, Shooter and Diana Pope, without whom none of this would be possible.

Dr. Neil Jumonville, history professor at Florida State University, who unwittingly gave me the idea to write this book.

George Combs, director of the Alexandria Library's Special Collections. His help tracking down sources was invaluable.

Brandy Crist-Travers, whose photographs helped bring a long-ago era to life again.

THE FORGOTTEN DISTRICT
OF COLUMBIA

Like many great ideas, the concept for this book was born at Martin's Tavern in Georgetown. Over drinks with Dr. Neil Jumonville, who was then the chairman of the Department of History at Florida State University, I explained that Alexandria and Georgetown were once rival sister cities that were both part of the original District of Columbia.

"They were?" he asked incredulously as we sat in Booth 21 of the historic tavern where New Deal policy was hammered out in the 1930s.

"Sure," I responded. Just look at a map. Notice how the boundaries of the District of Columbia look like a perfect diamond shape until it reaches the Potomac River. Then it looks like moths have eaten the southern third. Originally, I told the professor, the District had a perfect diamond shape, and it included modern-day Arlington and Alexandria.

"I had no idea," he responded.

That's when I knew I was on to something. Many people today have no idea that the District of Columbia once spread its dominion to the other side of the Potomac River, including people who live in Arlington and Alexandria. Unwilling to situate the nation's new capital city in a wilderness, leaders in the early federal period drew the boundary of the new capital city to include two existing cities: Georgetown, Maryland,

One of the few traces that Alexandria was ever part of the District of Columbia is this drainage pipe, which is located near the northwest corner of Prince and Fairfax Streets. *Brandy Crist-Travers.*

and Alexandria, Virginia. The plan's strongest advocate was none other than George Washington, who worked behind the scenes to make sure that Alexandria was included in the District of Columbia.

When the smoke cleared, the newly formed district had three distinct city governments: Washington, D.C., Georgetown, D.C., and Alexandria, D.C.

It was a time of new beginnings and radical adjustment, a period that historian Daniel Walker Howe described as the "transformation of America." The era saw an embrace of universal white manhood suffrage, the construction of powerful political parties and the pursuit of Manifest Destiny. For an indication of how rapidly the nation was changing during this time, consider the eight years Andrew Jackson served as president of the United States. He arrived in the District of Columbia on a horse-drawn carriage, but he left on a locomotive train.

In many ways, it was a time when the world was young and anything seemed possible. Vice President Martin Van Buren presided over the Senate with a pair of pistols as a precaution against frequent outbursts of violence. The *New York Sun* reported that creatures with furry bodies and batwings lived on the moon. Until the 1830s, Americans did not eat tomatoes, which were considered poisonous and referred to as "love apples." Baseball was conceived. As late as 1842, Charles Dickens called the capital "a city of magnificent intentions."

"The District of Columbia, like the United States as a whole, embodied big plans but remained mostly empty," Howe wrote. "America and its capital city lived for the future."

But this diamond was not forever. People in Alexandria were unhappy citizens of the District, and the problems began almost immediately. The newly formed District had no legal code, leaving Alexandria trapped with a stagnant legal structure that imposed the death penalty for seemingly minor infractions. They were unable to get the federal government to invest in basic municipal services, such as a sewer system, let alone constructing any buildings to house the official duties of the republic.

Meanwhile, the citizens of Alexandria were hidden in plain sight as their city fell into a state of suspended animation. Rival teams of firefighters sabotaged one another on the way to save lives. Dueling mania was rampant, turning every insult into a potential gunfight. Economic speculation tended to be overly optimistic, leading to some colossal business failures. And despite being exiled from presidential politics, the citizens of Alexandria formed a political identity apart from their neighbors in the District yet distinct from their brethren in Virginia.

Looming in the shadows was the specter of slavery, which became one of the city's dominant institutions. Even when people started talking about returning Alexandria to Virginia—called "retrocession" in the language of the era—the topic of slavery was barely mentioned. Yet the fear that slavery would be outlawed in the District of Columbia was justified, as it turns out. By the time that happened, though, Alexandria had successfully removed itself from the District and returned to its motherland.

The history of Alexandria, D.C., has been hidden for too long. Now, at last, its secrets are revealed.

HAIL, COLUMBIA!

The Secret History of Washington's Conspiracy

In the days after America's revolution, one of the most pressing debates of the era was where to locate the new nation's capital. Several sites emerged as leading contenders, and the public good was at the center of the discussion. But private gain was undoubtedly on the minds of many Alexandrians, including George Washington, who played a hidden yet significant role in locating the capital near Alexandria.

Washington was part of a team that surveyed the city in 1749, helping to carve an urban grid out of a Virginia wilderness. He attended meetings there as a justice of the peace at the court, drilled the Fairfax militia in the streets and is generally considered to be a father to the town. And he was not about to have the seat of government be located anywhere else. Yet the history of how Washington worked with Alexandria leaders in a gentleman's conspiracy has been hidden.

The story begins in 1783, as the diplomats were negotiating peace between Great Britain and the upstart new nation. During an October session of Congress, Massachusetts delegate Elbridge Gerry moved that his colleagues in the Confederation Congress consider creating what he called "a district" that would serve as the capital of the new nation.

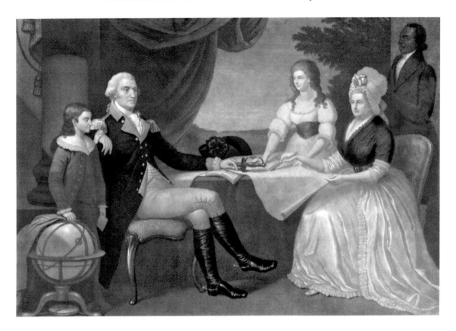

George Washington worked behind the scenes to make sure that Alexandria was included in the District of Columbia, shown here on a map surrounded by the Washington family. Notice that Washington's left hand is on the map, while his right hand is on George Washington Parke Custis. *Library of Congress.*

But it was not the District of Columbia as we now know it. Gerry suggested that the new capital be located at either Trenton on the Delaware or Georgetown on the Potomac, and his colleagues approved the site on the Delaware by a vote of eighteen to twelve. But then, ten days later, Congress approved a measure to erect buildings on the Potomac near Georgetown. The idea was that Congress would conduct its business in one capital for part of the year and then move to the other capital for the remainder of the year.

But that plan was never to be. More than a year later, in December 1784, members of Congress modified the arrangement by voting to eliminate the Potomac location altogether. Instead, they planned on establishing a federal district on the Delaware River. For the Virginia elite, the dream of locating the seat of government was about to slip away forever. That's when Washington entered the scene, playing a quiet role in the months and years ahead in shaping events that led to the selection of a Potomac site in defiance of the Congress.

Washington's strategy started by calling for an end to the discussion, at least for the time being. He encouraged Virginia delegate William Grayson to gather enough votes to block all further appropriations, a move that successfully stalled the conversation until after the ratification of the federal Constitution in 1788. By the time the First Congress assembled in New York, the issue of where to locate the permanent capital had become one of the hottest topics of conversation among the newly elected congressmen. Five locations emerged as leading contenders: Philadelphia, Baltimore, Germantown, Trenton and Georgetown.

Presiding over the discussion as the newly inaugurated president of the United States was none other than George Washington, a man who had a direct financial interest in the matter. In his farewell address to Alexandria on his way to New York to assume the presidency, Washington declared that it would be unnecessary to make a public declaration "of my attachment to yourselves, and regard for your interests…My past actions, rather than my present declarations, must be the pledge of my future conduct."

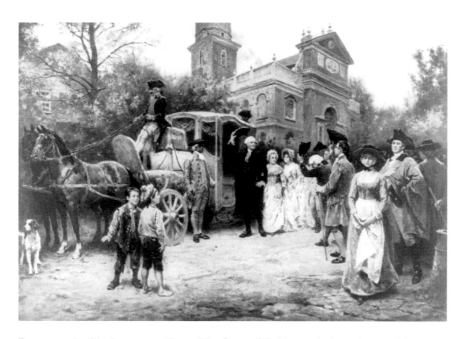

Demonstrating his closeness to Alexandria, George Washington is shown here arriving at Christ Church, although the artist has taken liberties with the appearance of the building. *Library of Congress.*

By 1794, Washington owned nearly twenty thousand acres along the Potomac River. He had already organized the Patowmack Company to build a canal around the falls to open the river to navigation, and he stood to gain financially by developing the river into the best route into America's heartland. Bringing wealth to Potomac merchants would increase land values along the river, including his own. The public would benefit, and Washington would make a profit along the way.

"This did not seem in any way unethical to him," observed historian Donald Sweig, "nor, for that matter, to most men of his time."

But it wasn't something that he wanted to publicize. In fact, Washington did everything in his power to obscure his role in the debate about where to place the capital—until the end, when he was given power to make the decision and ultimately disregarded guidelines from the Virginia General Assembly and the United States Congress. While there is no reason to suggest that Washington ever acted out of purely selfish motives, it's clear that his financial interest was tied to the Potomac River and Alexandria.

Although Washington's support for a capital on the Potomac was well known in Congress, he maintained a scrupulous silence on the issue. He didn't want to be seen taking sides in a sectional dispute, so he used silence as a weapon. Yet his lack of public statements on the matter doesn't mean that he maintained a private silence. His behind-the-scenes maneuvering to place the capital where it would be most financially beneficial to himself may be the first smoke-filled-room decision in American history.

The conspiracy began in 1789, a time when it was looking increasingly clear that a Potomac capital was slipping out of reach. Southern congressmen tried to strike a deal with the Pennsylvania delegation to support a permanent capital on the Potomac in exchange for a temporary one at Philadelphia. But the New York delegation thwarted this plan by offering its own deal: a permanent capital in Pennsylvania for a temporary one at New York. A majority of members in the House took the bait, but a parliamentary move in the Senate stalled the deal shortly before adjournment.

This is when the southerners began a major campaign to seize the capital. In September 1789, a petition was presented to the House of Representatives by "sundry inhabitants of Georgetown" offering to place

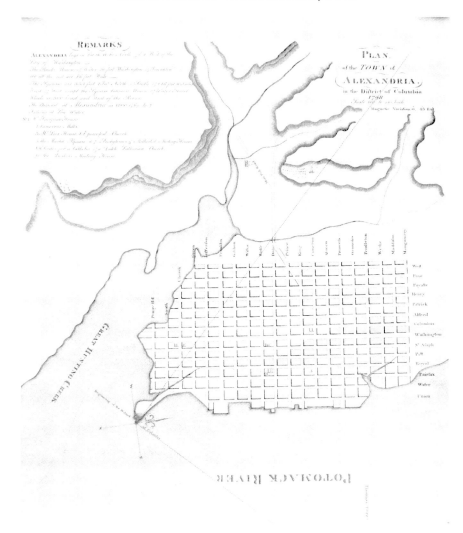

An early map shows how the District of Columbia boundary cut through the streets of Old Town. *Alexandria Local History Special Collections.*

themselves under Congressional jurisdiction if Georgetown should be selected as the seat of government. Nothing came of this offer, but a few days afterward the Virginia General Assembly took a bold action by passing an act "for the cession of ten miles square…for the permanent seat of general government." The wording of the preamble specified that Congress should select a site where "the states of Pennsylvania,

Maryland, and Virginia may participate in such location." Members of the General Assembly felt the need to specify that the site should be "above the tide water." Considering the fact that Alexandria is far below the falls, it seemed clear that Congressman Henry Lee, who introduced the bill, did not have the city in mind.

But others did. The same day the Virginia General Assembly passed the Cession Act, an Alexandria businessman by the name of David Stuart wrote to President Washington informing him of a meeting held by the merchants of Georgetown and Alexandria. Stuart explained that a committee had been formed to correspond with the towns of New England in an effort to provide them with "the most flaming accounts" of the Potomac "and the greater benefits they will derive" from placing a capital there rather than on the Susquehanna or the Delaware. Four days later, a broadside was issued at Alexandria setting forth the attributes of the Potomac as the best possible location for the capital. Although the broadside was not signed, historians generally recognized Stuart as the author.

Stuart's broadside declared it "universally admitted" that the seat of the new federal government should be as near the center of the territory as possible and then explained why the Potomac was an ideal choice. Part of the broadside included the number of miles from various creeks, rivers, falls and towns on the Potomac to one another. It also included a lengthy passage from Jefferson's *Notes on the State Virginia* about the advantages of the Potomac and Alexandria compared with the Hudson and New York when trading with the "Western Waters." The broadside extolled every known benefit, including the "fertility of the soil, salubrity of air" and the all-around awesomeness of the Potomac.

The broadside ended with a brazen polemic against New England, pointing out the disadvantages that merchants would have if the capital was located on the Delaware or Susquehanna, at Baltimore or Philadelphia. It concluded that "it appears evident that the produce, manufacturers and shipping of your country would be in much greater demand on the Potomack, than any where else more to the northward."

To understand Washington's involvement with this effort, it's essential to know who Stuart was. This was a man educated at the College of William and Mary who later studied medicine at Edinburgh and

Paris before settling at a plantation known as Abington on the river in Alexandria County, later known as Arlington County. He represented Fairfax County at the Virginia ratifying convention and later became a proprietor of Washington's Patowmack Company. Not only was he aligned with Washington's Federalist politics, he was also married into the family, taking as a bride the widow of Martha Washington's son, John Parke Custis. In other words, Washington's connection to Stuart's broadside was, in the words of Donald Sweig, "too obvious to be overlooked." Sweig further explained it this way:

> It advocated the location of the national capital at or near the general's hometown. It supported his argument with specific points known to reflect his views. It was written by a man, who through marriage was accepted as a member of Washington's family, and was signed by nine other friends and business associates. And Washington's total silence on the matter surely reflected his approval of the sentiments expressed in the broadside as well as the ends it was designed to accomplish. It would not be the first time that a prominent man, unable to speak for himself, had allowed, or encouraged, others to speak for him.

Stuart's broadside became the centerpiece of the conversation about where to locate the new nation's capital, and it was sent to selectmen and "influential characters" in Massachusetts and other New England states. It was also reprinted in a number of newspapers, including the *Massachusetts Centinel*, the *Worcester Gazette*, the *Gazette of the United States* and the *Maryland Journal and Baltimore Advertiser*.

The broadside and the buzz it created were reaching a crescendo when Thomas Jefferson visited Alexandria on March 10, 1790, on his way to New York to become the first secretary of state. Mayor Will Hunter hosted a public dinner, at which a number of toasts were exchanged. The mayor's remarks included "the most auspicious hopes from our arrival at this crisis…when subjects of the highest importance to the Union must necessarily be discussed." Considering the city's hopes of becoming part of the nation's capital, the implicit meaning behind the mayor's comments couldn't have been clearer.

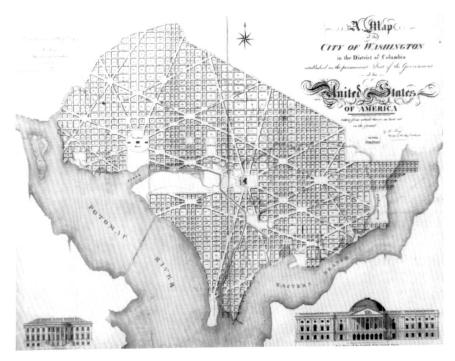

Surveyor Robert King's 1818 map of the city of Washington in the District of Columbia, including a depiction of the east front of the Capitol. *Library of Congress.*

Yet even with the coordinated campaign to place the capital on the Potomac, Congress did not take action. Not yet. For the time being, things appeared to be at a standstill. Or perhaps they were slipping away. In April, Congressman James Madison said that the prospects for the Potomac site were "pretty much out of sight." That was when the conspiracy kicked into high gear.

"We learn that some bargain is afoot between Pennsylvania and the Eastern States respecting the seat of Government founded on the assumption business," Stuart wrote to Richard Bland Lee in late May. Yes, a bargain was afoot. Perhaps the greatest bargain of the era, known to many as the Compromise of 1790. In what was probably the greatest vote-swapping operation of the age, advocates for a Potomac capital struck a compromise with advocates for "assumption" (the idea that the federal government should assume all the state debts from the recent war). This was an idea unpopular in the southern states, which had

largely paid off the debts, and popular in the northern states, which had not.

At this point, the politics of power merged with the lure of money. If the deal was struck properly, everybody would get what they wanted. Alexander Hamilton would get a powerful federal government, one that owned the debts of the states and, therefore, their fealty. David Stuart—and by extension George Washington—would get a seat of power on the banks of the Potomac River. The grand bargain was indeed afoot. It just needed the right setting. This is where Jefferson stepped into the scene, willing and able to follow through on cheerleading from *Notes on the State of Virginia*.

In June 1790, Secretary of State Jefferson hosted a dinner party at his home in Philadelphia with two very special guests on the list: Secretary Hamilton and Congressman Madison. Over a meal and perhaps a few glasses of Madeira, a compromise was arranged. Hamilton would do whatever he could do to secure passage of the residence bill. In return, Madison agreed to use his influence to get the assumption bill passed.

For Hamilton, this meant exerting his influence in New York and among the business elite. For Madison, this meant persuading members of the Virginia delegation to change their votes on assumption—most notably, Richard Bland Lee and Alexander White. These were the congressmen who represented districts along the Potomac River where the federal city could be located. Lee represented the counties of Fairfax (which included Alexandria and what would later become Arlington), King George, Stafford, Prince William, Loudoun and Fauquier. White represented a huge swath of land that included everything north of Loudoun.

White and Lee each hoped that the capital would be placed in his district. As far as Lee was concerned, the forces pushing for a capital including Alexandria were clear. But why did White switch his vote? Clearly he believed—or perhaps he was allowed to believe—that the federal city would be located within his Congressional district. It was, after all, above the tidewater and in a location where Pennsylvania, Maryland and Virginia could all participate—the stipulations laid out by the Virginia Cession Act of December 1789. The only place that met these criteria was, in fact, White's Congressional district.

Sully was Theodorick Lee's plantation estate in Chantilly, Virginia. *Library of Congress.*

But White was duped. Jefferson was in on the ruse, writing to George Mason on June 13 of the "temporary seat at Philadelphia and the permanent one at Georgetown." Perhaps the best proof of the secret deal is a letter from Congressman Richard Bland Lee to his brother, Theodorick Lee, at Sully, his plantation home in Fairfax County.

"Georgetown, as is probable should be the fortunate spot," the congressman wrote in a June 26 letter. "Tho the public buildings will be erected in Maryland, the bill will be so formed as to admit Alexandria if it should be deemed proper into the ten mile square."

In other words, all of that talk about placing a capital upriver had been intentionally designed to deceive. At the center of the tangled web was President George Washington, who would ultimately have the final say in where the capital would be located. But Congressman Lee had to get the bill through Congress first, by hook or by crook. "We are not confined to a particular spot on the Potomac," he told his colleagues in the House in July. "Baltimore is as far South as the place proposed."

The ruse worked. On June 28, the Senate introduced a residence bill specifying that the capital could be placed anywhere on the Potomac

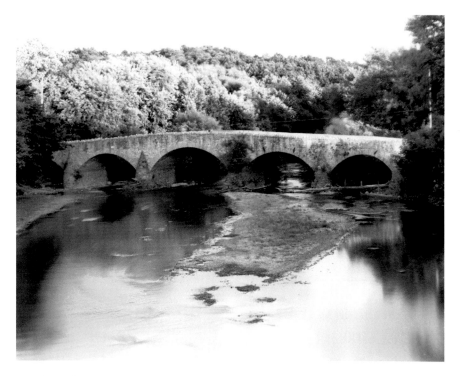

The Green Castle Bridge over the Conococheague Creek, a tributary of the Potomac River. *Library of Congress.*

"between the Eastern branch and the Conococheague." Today, we call the eastern branch the Anacostia River, a well-known river running alongside where the Washington Nationals play ball. Then, as today, the Conococheague was an obscure creek at Williamsport, Maryland. In other words, it was, quite literally, a backwater.

The only member of Congress who understood what was happening was a man by the name of Eldbridge Gerry. That's the same Gerry whose name would later be incorporated into the verb "gerrymander" when he tried to redraw the boundaries of the Massachusetts state legislature to benefit his party. This was a guy who knew a thing or two about boundaries. He described the Conococheague site as "a measure too ridiculous to be credited," a potential location that was offered as "a mere political maneuver."

"Enquiries will be made, where in the name of common sense is Conococheague?" asked Gerry. "And I do not believe one person in a thousand knows that there is such a place on earth."

Was the new nation really going to move from Philadelphia to a backwoods tributary in the Maryland wilderness? Gerry knew that this was simply an attempt to dupe Congressman White, one that seemed to be working. So he moved to unmask the conspiracy, introducing an amendment that would place the southern boundary for the federal city not at the eastern branch but instead at Hunting Creek—just south of Alexandria.

Gerry's amendment was defeated, and the debate continued along the earlier lines. By offering Hunting Creek as the southernmost boundary for the capital city, he was recognizing the influence that David Stuart's broadside was already having on the debate behind the scenes. Yet the public contours of the conversation continued to stretch from Conococheague to Anacostia, the vast majority of which is above the tidewater.

The House passed the residence bill on Friday, July 9, 1790, specifying that the capital be placed on the Potomac between the eastern branch and Conococheague, leaving the exact location to the discretion of President George Washington. But that wasn't the end of the story. It was only the beginning of the intrigue.

"The Alexandrians, as usual, are very much buoyed up on the Occasion, and think their Fortunes made for ever," George Mason wrote on April 16, 1791, "altho' it is evident, to any cool impartial sensible Man, that if the Inland Navigation of Potomack & Shanandoe is effectually completed, & the Seat of the Federal Government fixed near the Harbour of the Eastern Branch, Alexandria must become a deserved Village."

Commissioners paced nervously back and forth in front of John Wise's hotel as prominent members of the community began arriving on the afternoon of April 21, 1791. The occasion was the ceremonial placement of the southernmost cornerstone for the District of Columbia, an event that would include all the elements of Masonic pomp and circumstance: corn, wine, oil, aprons and trowels. When Mayor Philip Marsteller realized that the party was ready to walk to Jones Point, a toast was offered: "May the stone we are about to place in the ground remain an immovable monument of the wisdom and unanimity of North America."

The Jones Point lighthouse was built at the southern boundary stone of the District of Columbia. *Library of Congress.*

When they arrived at Jones Point, the cornerstone was laid by none other than David Stuart, the man who had been at the center of the conspiracy to secure a capital city on the Potomac with Alexandria incorporated into its borders. Now the first boundary marker was being laid conspicuously in Alexandria, completing the task. James Muir offered the blessing. "Of America, it may be said as it was of Judea of old, that it is good land and large," he said. "May this stone long commemorate the goodness of God in those uncommon events which have given America a name among the nations. Under this stone, may jealously and selfishness be forever buried."

The Four-Year Itch

An Uneasy Start for Alexandria, D.C.

A lexandria did not get off to a good start as part of the District of Columbia. Confusion became the order of the realm as indifference and disorder provided a backdrop for the infighting that festered between various interest groups. The lines of authority were anything but clear, leaving a vacuum that left the part of the District south of the Potomac in a sort of no man's land—without a clear legal identity of its own. Congress didn't get around to writing a charter for Alexandria until 1804, leaving the city to use the Virginia code as its legal guide, even though it had already bid adieu to the commonwealth. A sense of lawlessness emerged as a result.

The problems started almost immediately. President John Adams arrived in October, and Congress gaveled into session in November. By December, the entire government had fallen into gridlock.

The election of 1800 was one of the wildest campaigns in American political history, and its dramatic conclusion cast the newly created District of Columbia into a state of upheaval. Because Alexandria was a merchant town, it was a hotbed of Federalist politics and, therefore, supported the incumbent president. But the rest of Virginia was solidly behind Vice President Thomas Jefferson. Apparently the rest

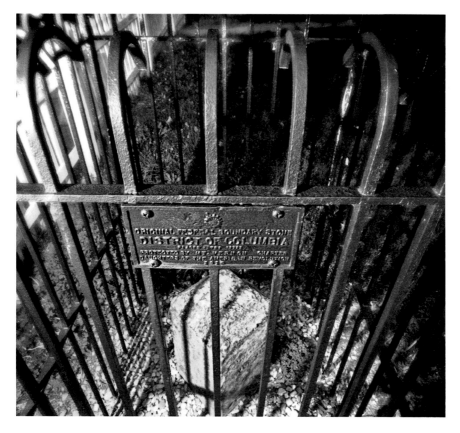

This boundary stone marked the original border between the District of Columbia and the commonwealth of Virginia. *Brandy Crist-Travers.*

of the country was just as divided, although in a different way. By late December, the shocking conclusion to the bitter campaign had become clear—the Electoral College was tied between Jefferson and Aaron Burr with exactly seventy-three votes each, sending the fateful decision to the House of Representatives.

Rumors and intrigue gripped the District. There was talk of holding a second national election, and it was unclear whether the Sixth Congress or the Seventh Congress should get to determine the winner. Federalists were plotting a scheme that would hand Federalist House Speaker Theodore Sedgwick executive authority for nearly the balance of the year. Jefferson became so concerned about this scheme that he attended every Senate session in January and February so

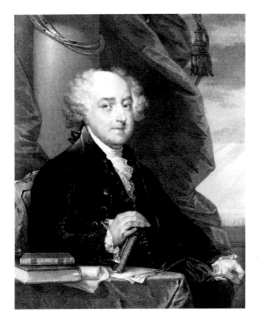

John Adams was popular in Alexandria, where he secured a majority of the votes for president in the controversial election of 1800. *Library of Congress.*

that he would be on hand to provide a tiebreaking vote if Federalists moved forward.

"It was a situation made to order for the Federalists, who reveled in conspiracy and intrigue," wrote historian Edward Nott. "The real excitement of the election of 1800 was how closely it came to being stolen and how the Federalists almost were able to defy the voters' mandate."

Meanwhile, on the other side of the Potomac, residents in Alexandria were becoming increasingly uneasy about their new situation. Fairfax County magistrates were no longer allowed to exercise their duties in Alexandria. But the Virginia magistrates had not yet been replaced by new ones. The sheriff of Fairfax County was no longer welcome. But there was no new sheriff in town. Nobody represented Alexandria in Congress. By January 1801, the citizens of Alexandria petitioned members of Congress to do something—anything—to help clarify the state of limbo. In a document titled "Memorial of Sundry Freeholders and Inhabitants of the Town of Alexandria in the District of Columbia," a of prominent men pleaded for some kind of resolution. "Under these circumstances," the Alexandrians wrote, "the growth and prosperity of the town of Alexandria, will be greatly promoted by a uniformity of laws within the district of Columbia."

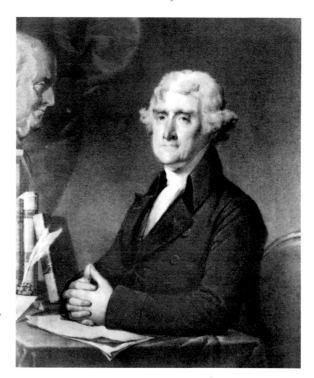

Thomas Jefferson was popular in Fairfax County, where he won a majority of the votes in the heated election of 1800. *Library of Congress.*

The Alexandrians had two suggestions, which they laid out in the document buried in a dusty corner of the Library of Congress. First was the establishment of a system of legislation and government for the District of Columbia based "on principles of rational liberty and free government." The second was to introduce a constitutional amendment that would give residents of the District Congressional representation. The former would take years, and the latter would never happen.

By mid-February, the House of Representatives was finally ready to take up the disputed election of 1800. According to the Constitution, the delegation from each state would have one vote to determine whether Jefferson or Burr would become the next president of the United States. In the event that a majority of the states in Congress did not vote for one or the other, that would potentially clear the way for another Federalist to emerge as the victor. And the Federalists were plotting a conspiracy to game the system.

The first balloting began on Wednesday, February 11. Eight states went for Jefferson, although Vermont and Maryland were deadlocked and therefore unable to cast a vote. Again and again ballots were taken, but they were unable to break the deadlock. As the balloting continued into the chilly February evening, congressmen sent out for nightcaps and pillows so they could take naps between the ballots in their chairs or on the floor of the chamber.

A visitor leaving the Capitol at sunrise the next day later observed that Congress was still in session and unable to break the deadlock. By the time Monday morning arrived, according to the *Alexandria Gazette*, there was still no resolution to the disputed election of 1800. Vote after vote, no winner emerged as the congressmen became intractably deadlocked. Six days and thirty-five ballots later, there was still no resolution. To many members of Congress, it must have seemed as though the March inauguration date would come and go with no winner in the election.

Outside the Capitol, noisy demonstrators shouted slogans for Jefferson. Several of them paraded through the streets with a large banner reading, "Jefferson, the Friend of the People." Six days into the voting, several Federalist congressmen who had been supporting Burr caved. They decided to cast blank ballots and end the deadlock, giving Jefferson ten votes and Burr four. As news of the House vote spread, the party faithful fired guns, rang bells and proposed toasts to "Jefferson, the Mammoth of Democracy." In Alexandria, thoughts turned to the city's newfound status as a city without a state.

"It being now ascertained that there is to be a new order of things," wrote an individual identifying himself as "B" in the February 18 issue of the *Alexandria Gazette*, "it is hoped the virtuous and energetic majority in Congress will, before the termination of the session, pass such laws for the government of the Territory of Columbia as will ensure to Alexandria stability and progressive commercial prosperity."

In the midst of the electoral drama, the District of Columbia was taking shape. On February 27, 1801, the lame duck Congress passed an act providing that the laws of Virginia and Maryland, "as they now exist," would be in force in that part of the District of Columbia. The act divided the District into two counties, Washington County to the east of

the Potomac and Alexandria County to the west. The act also created a circuit court of the District of Columbia and an orphans court.

"Thus the anomalous condition was presented of two contiguous counties, under the same legislative jurisdiction, governed by different systems of statutory law, to be administered by the same court," wrote District of Columbia Supreme Court justice Walter Cox in 1898. "Not until 1816 did Congress seem to awake to the importance of a general and uniform amelioration of existing laws."

That vacuum created a sense of lawlessness in Alexandria, D.C. For sixteen years, the city was in a state of suspended animation. As Justice Cox noted, many of the sanctions were "suited for barbarous ages." For example, the criminal statutes in Maryland were frozen in time, prescribing capital punishment for a dozen offenses, including arson, breaking into a shop and stealing five shillings worth of goods,

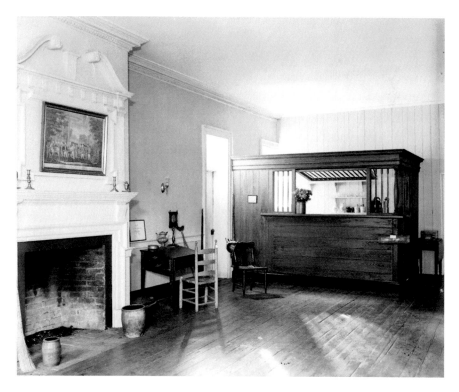

An interior view of Gadsby's Tavern, where Thomas Jefferson held his inaugural banquet in 1801. *Library of Congress.*

stealing a boat or in "the case of a negro burning tobacco or stealing a horse."

For his inaugural banquet, Jefferson chose Gadsby's Tavern in Alexandria to be the scene of the party. On Saturday, March 16, 1801, the full panoply of power arrived in Alexandria, D.C. The guest list included the president, vice president, secretary of war and attorney general.

President Jefferson and his party arrived at about 2:00 p.m., escorted by a federal cavalry detachment. They were met by a volunteer rifle company at the northern edge of the city, where a uniformed militia escorted them to King Street and followed them as they passed for review. Their arrival was announced with sixteen artillery rounds and sixteen rounds of musket fire.

"The company who partook of the entertainment was the largest ever known at a public dinner prepared at any tavern in this town," the *Alexandria Gazette* noted. "And the style and elegance which it was furnished, at so short a notice, reflect the highest credit on the taste and industry of Mr. Gadsby."

All twenty-three windows of the hotel were "elegantly illuminated," creating a brilliant sight that was surely burned into the memory of those who witnessed it. *Gazette* editor Samuel Snowden noted that it was with "infinite satisfaction" that the city observed "a unanimity of sentiment and harmony of feeling." After dinner, sixteen toasts were given—including everything from remembering the legacy of George Washington and Benjamin Franklin to honoring the newly inaugurated president and, of course, cheering the "prosperity of the town of Alexandria."

"We indulge the hope that it is the precursor of those happy affects expected to result from the new administration," Snowden wrote. "We anticipate with pleasures a union of parties for the public good."

The union of Alexandria and the District of Columbia was not a pleasurable one, and the problems weren't limited to domestic affairs. By the time the District was created, Alexandria had a solid reputation as one of the most important port cities on the eastern seaboard. Newspaper columns from the 1790s were filled with notices from ships across the globe, from China to Spain, Holland, Jamaica, Portugal, Germany, France and Russia. The waterfront bustled with public and private

wharves, and large shipping firms prospered in international trade. The largest customer of Alexandria was the West Indies fleet of the Royal Navy, which purchased a huge amount of flour for sea biscuits.

Yet almost as soon as the city became part of the newly formed District of Columbia, it fell into a state of decline. By 1801, more than twenty Alexandria vessels had been captured by French privateers. Their cargos were confiscated and their crews imprisoned. Adding insult to injury—or perhaps the other way around—a yellow fever epidemic struck the city in 1803, claiming more than two hundred citizens. The twin disasters of piracy and disease took their toll on the city's reputation.

"These shocks have deeply affected the mercantile interest, that the town has but two or three ships in the trade with Great Britain," an English traveler wrote in 1807. "And there is little prospect of its ever attaining to its former prosperity."

As merchants struggled with the quasi-war with France, and doctors labored against a growing epidemic, the city's legal community was in a sort of no man's land. Stepping into this void to impose order on the chaos was a Massachusetts man by the name of William Cranch. Born into an influential family, his father was a judge of the Massachusetts Court of Common Pleas. Yet Cranch struck out on his own, arriving in the newly created capital at the age of thirty-three to become the first judge of the circuit court of the District of Columbia in Alexandria.

Judge Cranch found himself in a hall of mirrors when he gaveled the court to order in April 1801. The first session was held in the Hustings Court building, which was located on the north side of Market Square. Cleon Moore was appointed clerk of court, and a bar of eight attorneys took their oaths. The first case on the docket was for a man named Jacob Leap, who was charged with the illegal sale of liquor. It seemed simple enough, but the judge found himself in uncharted legal waters.

Which laws was he supposed follow? Alexandria was no longer in Virginia, yet the District of Columbia had no laws. In a preface to the first volume of court documents for the circuit court, Cranch explained that—for now, anyway—the laws of Virginia and Maryland applied to the sections of the respective states ceded to create the District. The case is styled *Commonwealth of Virginia v. Jacob Leap*, even though it was

Artist William Russell Birch created this etching depicting an eagle holding a stars-and-stripes shield above the construction of the two wings of the United States Capitol. *Library of Congress.*

tried in the District of Columbia, setting an important precedent for the court even if the case was somewhat of a dud. After hearing from the prosecutor and the defense attorney, Judge Cranch dismissed the case on a technicality.

"The court arrested the judgment on the ground that it did not appear by the verdict that the fact was committed before the information was filed," Cranch wrote on the first page of *Reports of Cases Civil and Criminal in the United States Circuit Court of the District of Columbia.*

In later years, Leap would be compared to the bootleggers of the Prohibition era for taking advantage of a technicality. Writing in the *Washington Post* in 1930, reporter Dunbar Hare wondered whether Cranch would have devoted more space to the issues in the Jacob Leap case "if he had visualized the age of prohibition." He then castigated Leap for

"taking advantage of the law in order to avoid penalty of the statutes." But this was all in a day's work for Judge Cranch, who would remain on the court until Alexandria's return to the commonwealth.

"He was more than once called upon to carry out laws which the present day deems palpably unjust," explained historian William Carne. "And it is evident that he did so with the most childlike, bland and implicit confidence that the law of the land was the highest expression of human wisdom."

Apparently, this meant even when the law was an ass. Consider, for example, how the city's legal limbo created a death penalty for theft. Yes, countless two-bit pickpockets were hanged in the town square. Once again, it was an untenable situation created as an unintended consequence to the creation of the District of Columbia. The old laws that made theft a capital offense had been repealed in Maryland before the cession of Washington County. But Virginia didn't repeal the provision until after giving Alexandria to the District.

"And so," Carne concluded, "that 39 square miles of territory stood in 1820 alone in America in making life the price of stolen goods." Alexandria was a city without a charter, limping along with a 1779 charter that was intended for a different time and a different purpose.

Mr. Madison's War

Alexandria and the War of 1812

Many people consider Vietnam as the first war America lost. But as historian Paul Boller points out in his book *Not So!*, that's, well, not so. The War of 1812 was a disaster—literally and figuratively. It left many parts of the Washington, D.C., ravaged by fire, although the invading British forces spared Alexandria, D.C. When the smoke cleared, the city was left with an undeserved reputation for cowardice and a bruised ego.

It all started in the summer of 1812. After months of being pressured by the "war hawks" on Capitol Hill, President James Madison finally relented. In a message to Congress, he asked members to consider declaring war as a result of the British interfering with neutral rights at sea and impressment of American seaman into the British navy. But the real motivation for the war was Canada. Along with East Florida and West Florida, Canada was the only British colony to remain loyal to the Crown in 1776.

The British in Canada supplied the western Indians with arms and ammunition to use against the Americans. So the impressment of American sailors, known as "manstealing," became a threat to national pride. There was also a sense that the territory of Canada really should have thrown in its lot with the rebels in 1776 and that they would

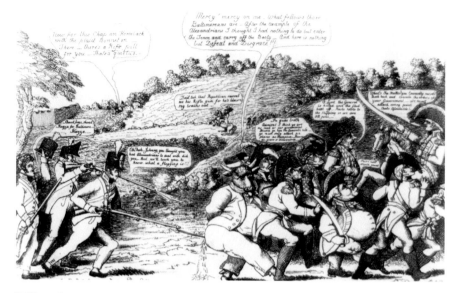

William Charles's cartoon "John Bull and the Baltimoreans" shows Marylanders resisting British encroachment. *Library of Congress.*

welcome the yanks with open arms. During a debate about the war, Kentucky Congressman Richard Johnson took the floor of the House of Representatives to castigate "the occupation of Canada and the other British possessions upon our borders, were our laws are violated, the Indians stimulated to murder our citizens, and where there is a British monopoly of the peltry and fur trade."

"I should not wish to extend the boundary of the United States by war if Great Britain would leave us to the quiet enjoyment of independence," Johnson continued. "But, considering her deadly and implacable enmity, her continued hostility, I shall never die contented until I see her expulsion from North America and her territories incorporated into the United States."

Fat chance. America was staring down the barrel of the mightiest navy in the world, a force that could crush the upstart new nation. The debate quickly became partisan. Members of President Madison's party, the Republicans, cast their ballots for war. The Federalist opposition party, which thought that the United States should side with Britain against Napoleonic France, voted solidly against it. By the time the final vote took place on June 4, 1812, the vote was seventy-nine for war and forty-

nine against the conflict. The Senate took up the issue on June 18, with eighteen yeas and thirteen nays.

The war began with a great deal of support. But that only degraded over time. Like Vietnam and Iraq, the War of 1812 produced vociferous opposition. When it all began that summer, the war hawks thought it would be quick and easy. "On to Canada," was the cry heard among the supporters. Leading war hawk Henry Clay declared that the "militia of Kentucky alone" would be "competent to place Montreal and Upper Canada at our feet."

The *Alexandria Gazette* was opposed to the war. From the outset, Editor Samuel Snowden began asking questions about what might happen if President James Madison's planned invasion of Canada failed. "What pledge have we that a naval force will not be sent to lay our rich maritime cities under enormous contributions or raze them to the ground?" he inquired in 1812.

By all accounts, President James Madison's invasion of Canada had been a disaster, and Snowden's question seems prophetic in retrospect. War hawks in Congress assumed that Canadians would welcome the Americans with open arms and create an insurgency against the British. So once American General William Hull reached Canadian soil on July 12, 1812, he issued a proclamation ordering all British troops to surrender, or the "horrors and calamities of war will stalk before you." Yet the bellicose proclamation served only to stiffen resistance to the American cause, and the British military crushed the Americans and launched its own invasion of Washington.

Meanwhile, the Canadian misadventure depleted the federal treasury and left the District of Columbia exposed to attack. A call to arms for the defense of Washington removed all able-bodied men from Alexandria, and the city's citizens sent the Common Council a petition requesting that five cannons be mounted along the waterfront. The August 18, 1814 issue of the *Gazette* carried a shocking article headlined "Defense of District" in which Snowden exposed how the federal government had failed to prepare for a proper defense of the District.

"They have drained the public coffers of the last cent in vain and ridiculous adventures against Canada," Snowden wrote. He reported that

the republic was "already reduced to the extreme necessity of borrowing money from the pockets of individuals to enable them to defend the Capitol of their county from invasion."

In October 1812, a volunteer company of soldiers was raised in Alexandria. Although it was originally intended for use in the invasion of Canada, the men were assigned to Fort Warburton just below the District of Columbia on the Potomac River. In March, the Alexandria Common Council appointed a delegation including the mayor and president of the council to visit the secretary of war and request a supply of arms and ammunition for use of the militia in the defense of Alexandria. When it became clear that delegation did not produce the intended result, another delegation was dispatched. This time, the Alexandrians were sent to the Executive Mansion, where they met with President Madison on May 8, 1813, to apprise him of the defenseless position of the port city.

On the same day, the Common Council appropriated $1,500 to mount a cannon along the waterfront to pose some kind of defense. Three days later, the council appointed a Committee of Vigilance with the expectation that its members could consult with similarly appointed bodies in Washington, D.C., and Georgetown, D.C. The federal government responded by sending military engineers to Fort Warburton—first to declare it fit for the defense of the capital and then to reverse that decision and declare it unfit.

When the British began raiding the lower Potomac in April 1814, the Alexandria Common Council responded by approaching the federal government once again. Two months later, the military commander of the Tenth Military District visited Alexandria and declared that the city was, indeed, unprepared for military action. Yet he also pointed out that there was no money to prepare the city.

The British fleet had been operating freely in the Chesapeake Bay since the invasion, plundering and burning coastal towns and villages across the region. Yet threats to the young nation's capital always seemed to be false alarms—at least until the summer of 1814. That's when everything changed in Washington, and in Alexandria.

In August, a fleet of twenty-two British warships sailed into Chesapeake Bay. The flotilla was carrying three thousand infantry

troops who were hardened veterans of the Duke of Wellington's campaigns against Napoleon across the battlefields of Europe. The British commander of the North American Station, Sir Alexander Cochrane, was confident that he could strike a serious blow to the upstart Americans. Rear Admiral George Cockburn, who had been placed in charge of the Chesapeake Bay, had been planning all summer for an assault on the District of Columbia.

When the guns of August arrived, another Alexandria militia was raised and stationed between Piscataway and Fort Warburton. The militia took all of the city's artillery except two guns with no ammunition, essentially leaving Alexandria without able-bodied men or ammunition. On the night of August 24, the militia took another position in Georgetown. Realizing that the town was now defenseless, the Committee of Vigilance made a difficult recommendation to the Common Council: "In case the British vessels should pass the fort, or their forces approach the town by land, and there should be *no sufficient force*, on our part, to oppose them, with any reasonable prospect of success, they should appoint a committee to carry a flag to the officer commanding the enemy's force, about to attack the town, and to procure the best terms for the safety of persons, houses and property in their power."

Shortly after Major General Robert Ross arrived with 4,500 battle-hardened British regulars, Cockburn was able to persuade Cochrane that Washington could be taken. The admiral devised a two-pronged attack. First, ground troops would land at Benedict, Maryland, on the Patuxent River and head overland to Washington. Simultaneously, a naval force under the command of Captain James Gordon would approach Washington from the south up the Potomac River.

The British struck on August 19, 1814. Although the Americans attempted a hastily gathered resistance under the direction of General William Winder, the British easily steamrolled them on the way to the capital city. Meanwhile, the British squadron under the command of Captain Gordon inched its way up the Potomac. On August 27, he began bombarding Fort Warburton. Within two hours of the barrage, which began at 8:30 p.m., a tremendous explosion rocked the fort—

one that was orchestrated by defenders of the fort, as it turned out, to prevent the British from commandeering it.

That opened the river to British control. And so it was on to Alexandria, which had been anxiously awaiting the arrival of the most powerful navy in the world. The squadron had two rocket-ships with eighteen guns each, two bomb-ships with eight guns each, a schooner with two guns and two frigates, one with thirty-six guns and the other with thirty-eight guns. On August 24, the Alexandria Committee of Vigilance sent a delegation to the Executive Mansion to inform President Madison that the city was defenseless. Members of the delegation eventually tracked him down at Bladensburg, already overcome with intractable problems.

The delegation returned to Alexandria empty-handed. Once again, the federal government failed to deliver for the Virginia portion of the District of Columbia—this time to offer a basic military defense. As a result, the Committee of Vigilance recommended to the Common Council that surrender was the only option. When city leaders learned of the explosion at Fort Warburton, members of the council began assembling a delegation to meet the British commander.

"It is hard to imagine even the most patriotic citizens not seeking and accepting the British terms of surrender," wrote historian Joseph Skivora.

A three-man delegation was selected, and the group set sail to meet with Captain Gordon on his flagship, the HMS *Seahorse*. The captain refused to discuss terms of surrender until the fleet arrived at Alexandria, although he indicated that he planned to seize all of the ships and cargoes waiting to be exported. Members of the delegation protested that General Ross and Admiral Cockburn had not seized goods in Washington, although the complaint apparently fell on deaf ears.

As the negotiations between Alexandria and the British were in progress, Mayor Charles Simms learned that a regiment of Virginia militia was on its way to defend the city under the command of General John Hungerford. Simms sent word to Hungerford that resistance was futile and that Alexandria would be surrendering, requesting that the general keep his troops away from the city to avoid bloodshed. Hungerford responded that he would decide his course of action when he arrived at the city.

When the warships arrived along the city's waterfront, Alexandria sent a second delegation to the HMS *Seahorse*. This time, Captain Gordon had prepared and delivered specific terms of capitulation. They weren't favorable to the city. Essentially, the captain wanted the delivery of all naval and ordnance stores, merchandise, provisions and shipping. The introduction to the terms of capitulation explained it this way: "The town of Alexandria, with the exception of public works, shall not be destroyed, unless hostilities are commenced on the part of the Americans; nor shall the inhabitants be molested in any manner whatever, or their dwelling-houses entered, if the following articles are complied with."

The Alexandria Common Council accepted the terms in an effort to save the city and prevent bloodshed, an admirable move considering what had happened to the rest of the District of Columbia. Mayor Simms was able to score some victories for the city during the negotiations. First, he was able to remove a key passage requiring Alexandria to return supplies that had already been moved to the countryside. And he was able to remove a demand that the city refloat scuttled American ships.

The occupation of Alexandria lasted for five long days. Knowing what had taken place for the last two years in the coastal towns of the Chesapeake Bay, Alexandria residents feared the worst. Yet residents were in for a pleasant surprise. City leaders were able to soothe the wrath of their captors. City residents could not have been happy about the occupation, but contemporaneous accounts noted the surprisingly good behavior of the British troops during their time in the city.

"It is impossible that men could behave better than the Britissh [*sic*] behaved while the town was in their power," Mayor Simms wrote to his wife. "Not a single inhabitant was insulted or injured by them in their person or houses."

"Their conduct was respectful and decorous," added Edward Stabler, owner of an apothecary on South Fairfax Street. "Instead of that exultation and triumph which expands the heart of a soldier when he encounters and overcomes a force like his own, these were evidently dejected and adverse to what they were doing."

When the British squadron debarked in early September, Alexandria residents were counting their blessings that the city was spared the

fate of Washington. Sure, there were significant financial losses in terms of goods and ships. Yet there had been no loss of life nor no damage from enemy shelling. As Captain Gordon bugged out of Alexandria, city residents could resume their day-to-day lives satisfied that their leaders had charted a course that saved the city from certain destruction—actions that also saved the city for modern-day visitors as well as the present generation.

The occupation of Alexandria is not the kind of thing that the city's marketing department includes in brochures. In many ways, it's one of the darkest and most unknown aspects of the city's history—a diamond in the rough for the Carlyle House, which plays an interesting role in the occupation. William Herbert was living there in 1814. As president of the Bank of Alexandria—later Burke and Herbert Bank—Herbert was one of the city's leading citizens and a member of the committee that boarded the British ship and negotiated the surrender.

"A lot of people don't know about this chapter in Alexandria's history because it's not very flattering, really," said Mary Ruth Coleman, former administrator of the Fairfax Street museum. "The whole surrender thing just doesn't sound that great."

Unlike the rest of Virginia, which was squarely in support of Jefferson's Democratic Republicans, Alexandria was a Federalist town, and the *Gazette* was a Federalist paper. The city's business class had a lingering bitterness for a political caucus that imposed an embargo against England, which cut into the profits of the seaport's captains of industry. Nearly $100,000 worth of foodstuffs and grain was lost when the British entered the port and began pilfering.

"Besides the financial and monetary losses, Alexandrians were humiliated nationally because they had surrendered the town without a shot," said city historian Michael Miller. "The invasion was a major contributing factor that led to the demise of the seaport of Alexandria."

Today, people seem to appreciate the actions of Alexandria's leaders as having been a shrewd way of saving the city's people and infrastructure. Yet, at the time, reaction was fiercely negative. A famous political cartoon from the era shows British Johnny Bull presenting Alexandria leaders with terms of capitulation as a British officer calls the Alexandrians

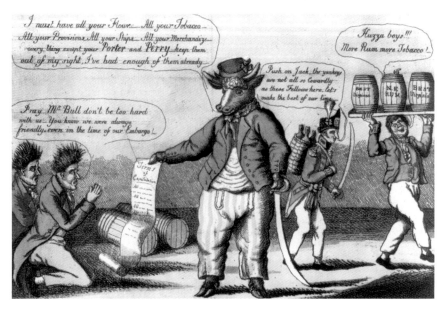

Artist William Charles's famous political cartoon "John Bull and the Alexandrians" depicts Alexandrians as frightened by the British, who are seen leaving with the city's spirits. *Library of Congress.*

"cowards" while making off with some rum and tobacco. "I must have all your flour, all your tobacco, all your provisions, all your shops, all your merchandise, everything except your porter and Perry," proclaimed the cartoon embodiment of the British empire. "Keep them out of my sight. I've had enough already."

The *Richmond Compiler* condemned city leaders for surrendering to an "enemy, to whose liberality and generosity they chose to confide their lives, and their *dear property* which they valued more than national or individual honor." That was just the beginning of the opprobrium.

"In what terms can we express our indignation against the conduct of the citizens of Alexandria?" asked the *Richmond Enquirer*. "Thanks be to the Almighty God that this degraded town no longer forms a part of the state of *Virginia!*"

The *National Intelligencer* was similarly disabused. "The degrading terms dictated by the Commander of the British squadron below Alexandria," the newspaper observed, "to the civil authority of that town, connected with the offer of the townsmen *before* the squadron had even reached

the fort, to surrender without resistance, and their singular submission to Admiral Cockburn whilst he was in the city, have everywhere excited *astonishment and indignation.*"

The *Richmond Enquirer* published a story that reported that Alexandrians were so fearful that the British would return that they continued to fly the Union Jack even after the occupiers had sailed south—only lowering the standard when Commodore Rodgers arrived and forced them to remove the flag. The *Boston Patriot* suggested part of the problem is that Alexandria had "scarcely a Republican in it." The *Niles Weekly Register* devoted an entire front page "editorial address" to the capture of Washington, D.C., and Alexandria, D.C. The *Register* castigated the British for behaving worse than Napoleon, although it took aim at Alexandria's leaders as well. "It is no matter that the conduct of the Alexandrians was base and pusillanimous, so as to excite rather the contempt than the pity of their countrymen," the newspaper wrote. "For it does not affect the *principle* of the terms offered by the enemy to a defenseless, non-resisting place."

Gazette editor Samuel Snowden was eager to set the record straight. In a series of strongly worded editorials, the editor sought to dispel what he called "falsehoods" that were "in circulation respecting the late occurrences at this town." He rejected the account from the *Richmond Enquirer* that Commodore Rodgers forced the British flag down. In fact, he denied that the Union Jack had ever been hoisted above the city in the first place.

"We can assure the public that the British flag was not hoisted at all by any of [Alexandria's] inhabitants or the British except on board their vessels," Snowden wrote. "The citizens of Alexandria never did desire or contemplate a surrender of their town."

Responding to the *Patriot*, Snowden explained that the Common Council and the Committee of Vigilance had "gentlemen of *both political persuasions.*" More importantly, Snowden wanted readers to know that no vessels were sunk, no aid was afforded to the enemy, no insult was offered to the people of the town and only small amounts of tobacco and cotton were taken from the city's warehouses. And the implication that the city's residents acted in a way that was cowardly or traitorously was incorrect.

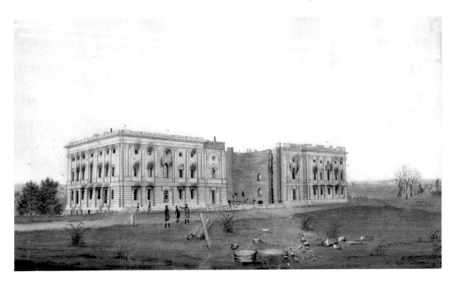

Artist George Munger's drawing shows the ruins of the Capitol following the British attempt to burn the building in August 1814. *Library of Congress.*

"Matchless impudence," exclaimed the *Gazette.* "Unparalleled upon the character of a virtuous and high-minded people."

By late September, members of Congress wanted to get to the bottom of what had happened. So they appointed a committee to inquire into the matter. The Committee of Inquiry issued a report that contained documents and depositions from many of the participants in the events of late August and early September.

The narrative of the committee's report begins in October 1812, when a volunteer company of soldiers was raised in Alexandria, and ends with a description of the occupation. Congressional investigators found no indication of collaboration or even cooperation with the British occupation forces. In fact, the report noted that the Alexandria Common Council refused to force the merchants to refloat their scuttled ships or recover merchandise they sent out of the city as the British approached.

It's difficult to imagine a scenario that could have unfolded better for Alexandria. City leaders could have ordered an evacuation, although that could have led to wholesale destruction. The mayor could have encouraged General Hungerford's militia to attack the British, but his

forces would have been no match for the British warships, which were packing more than one hundred guns in total. And there's no doubt that an attempt by the militia to repel the British would have resulted in the death of civilians and the destruction of Alexandria.

"The action taken by Mayor Simms and the Common Council was the only prudent alternative available to them, and they should have been commended rather than condemned for their judgment," wrote historian Joseph Skovia. "Their unjust condemnation can be laid squarely at the feet of some of the nation's press."

In an era when newspapers were still gaining power in the American political scene, the aftermath of the War of 1812 showed the power of the press to frame issues and shape opinions. But it also demonstrated that the system was flawed. Much of the early news was inaccurate and flavored with partisan bias and regional jealousy. The *Richmond Enquirer*'s exhortation thanking God that "this degraded town no longer forms part of the state of Virginia" is a case in point. Reprinted in the *Norfolk Herald* and the *Charleston Courier*, the insult spread across southern port cities in competition with Alexandria.

Yet while editors in these cities seemed eager to defame the reputation of a competitor, they seemed unwilling or unable to spend any time verifying the accuracy of what was reported. Even when the truth emerged, some newspapers were slow to publish it. Most of them took no steps to retract earlier mistakes. Fortunately for Alexandria, the report from the Congressional Committee of Enquiry forms the basis for a retrospective defense against the libelous accusations and mistruths that were published in the newspapers of the era.

FIRE!

Disastrous Conflagrations Ravage the City

Ever since Prometheus gave fire to man, it's been a pain. Man has learned to bend it to his will but has never become its master. One fire in Alexandria even sparked a heated debate in Congress that led to a duel, leaving a former congressman dead and another trying to explain what happened.

Yes, fire is a hot story. For residents of Alexandria, D.C., it was an ever-present danger, lurking in the shadows and exploding into the urban grid at the most unexpected times. That's why the city was one of the first in the United States to organize a volunteer fire department, chartering the Friendship Veterans Fire Engine Company in August 1774. Some say George Washington was a founding member, although others dispute that claim.

This was a time when firefighting was a grueling physical challenge. Men formed bucket brigades to hand off containers of water to the next available person until it got to the fire. Women and children participated in a reverse brigade to return the leather buckets to the source of water to start the whole process over again—until Washington, first in war, first in peace and first to fight the flame.

Washington himself may have purchased the city's first fire engine during a 1775 visit to Philadelphia, where, urban legend has it, he paid

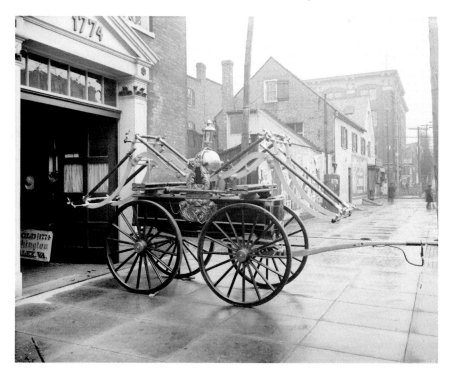

Urban legend has it that George Washington purchased this fire engine during a 1775 visit to Philadelphia, where he supposedly paid eighty pounds, ten shillings for the horse-drawn wagon. *Library of Congress*.

eighty pounds, ten shillings for the horse-drawn wagon. The vehicle is still on display at the Friendship Firehouse on South Alfred Street, although the historian of the Friendship Veterans Fire Engine Association said that Washington was never a member of the company and had nothing to do with the purchase of the engine. One thing is clear: Washington helped fight a fire in Alexandria, the details of which were reported in the pages of *Harper's Weekly*. According to the magazine, Washington was riding down King Street one day when a fire erupted near the market house. Noticing that the Friendship engine was poorly manned, the former president approached a group of men and called them to action. "It is your business to lead in these matters," he told the men before jumping into the firefight.

But Friendship Firehouse was not the only game in town. On January 12, 1775, about five months after Friendship was chartered, the Sun Fire Company was founded. It was originally located in Market Alley,

The view from the tower of Friendship Fire Company on Alfred Street. *Library of Congress.*

later moving to the corner of Fairfax and Cameron. Then came the Star Fire Company, established on March 4, 1799, with a firehouse on South St. Asaph. By the 1820s, yet another organization had entered the mix: the Hydraulion Fire Company, founded in 1827. Customers who were willing to pay the annual stipend were presented with a "fire mark," a plaque indicating which insurance company was responsible for guarding their house.

These companies were fiercely competitive, vying with one another for customers. Sometimes insurance companies would sponsor a particular group of firefighters. In some cases, firefighters declined to fight a fire if it was burning in a house or a building that displayed the fire mark of a

rival insurance company. Other times, insurance companies would offer a reward for whichever company would arrive to the scene of a fire first. That created a heated rivalry between companies, with firefighters often working overtime to humiliate one another. Passing a rival company on the way to a fire became a mark of distinction, and damaging a rival's equipment was considered fair game. Fights were common, and buildings became ruins while firefighters battled with one another over who would put out the blaze.

"Such occurrences are disgraceful," wrote Fire Chief J.C. Creighton in a May 7, 1789 memorandum after one such fight. "As the whole town looks to me for the suppression of such occurrences, it becomes my very disagreeable duty to notify the members of this Department that upon a repetition of these disgraceful battles I will be obliged to promptly order the arrest of all parties so engaged as they are directly violating the Fire Department laws as well as those of the State and Corporation of Alexandria."

The city's first truly catastrophic conflagration occurred on September 24, 1810. This was a time when author Washington Irving was making a name for himself in literary circles and fur traders were making designs deep into the Pacific Northwest. Here in Alexandria, something else was taking shape among the casks, barrels and butter churns along the city's waterfront. It began like many fires do, with a bit of neglect and a dash of bad luck. According to the *Alexandria Gazette*, the fire began at about 10:00 p.m. in Lawrence Hill's cooper shop near the wharves along Union Street, which was located on the east side of the street between Prince and Duke.

"A workman, leaving a candle in the shop, went out for a handful of staves," the newspaper reported. "On his return, he discovered that the candle had falling among some shavings."

The cooper could not stave off the fire before him, especially since the bits and pieces of material needed to construct casks and hogsheads were so combustible. Cries of "Fire!" rang out almost immediately, but those who ran to the scene found that the conflagration had already grown steadily into an unstoppable force of nature. For the next four hours, townsmen arrived on the scene to do battle.

Fire ravaged every building on the east side of the street, where the devastating bonfire had originated. Houses on the other side of Union

caught fire several times, although they were apparently saved by what the *Gazette* called "the great and imminently dangerous exertions of several inhabitants." One of the heroes that night was a twenty-five-year-old actor by the name of Spencer Houghton Cone, who was working among the shippers and commission merchants that evening.

"He exerted every power of body and mind to combat the raging element," wrote Edward Cone in an 1856 biography of his father, who would go on to become a famous Baptist preacher. "From midnight until the morning of the 25th he was seen everywhere at work amongst the flames."

Cone and the others battling the fire that night may have been helped, ironically, by another force of nature: the wind, or rather the lack of it, which helped those who were fighting the fire along Union Street until shortly after midnight. But even then it was a gust that fortunately moved in a direction that didn't imperil houses and buildings in the densely populated riverfront town. The *Gazette* reported that a breeze sprang up in the witching hour "bearing the flames to the river."

It was nearly 2:00 a.m. when the fire was finally under control, surely a relief to the townsmen who had been battling the smoke and heat for hours on end. The newspaper estimated that the heroic firefighting that September night probably saved about one hundred houses, but that didn't make the damage any less devastating. When all was said and done, the parade of destruction had marched through ten houses, eight warehouses, two lumberyards, a ship chandlery, a blacksmith's shop, a grocery, a bake house and, of course, the infamous cooper's shop where the fire had begun. *Gazette* editor Samuel Snowden estimated the damage at $200,000.

The city's most notorious fire, though, erupted during a frigid January day in 1827. It began accidentally in James Green's cabinetmaking shop near 112 South Royal Street and spread quickly to level several blocks of the city. By the time it was over, the United States Congress was debating whether or not the city of Alexandria should receive $20,000 for the aid of citizens who became homeless and destitute as a result of the fire. Bitter feelings from that debate sparked a duel, leaving one participant dead and forever changing the life of the other.

After the fire destroyed his factory, James Green built a new factory at the southeast corner of Prince and Fairfax Streets. His initials are still on the side of the building. *Brandy Crist-Travers.*

It all began innocently enough, originating in the workshop of James Green, a prominent cabinetmaker whose building was located in the interior of the square bound by the east side of South Royal between King and Prince. The alarm sounded a few minutes before 9:00 a.m. on January 18, 1827. But Green's workshop was filled with material that was highly combustible. Before help arrived, flames had already spread from that house to others nearby.

It was freezing cold, with temperatures dipping to a bone-chilling fifteen degrees. This made the water, which was pumped from the Potomac River, descend from the hoses in ice and sleet. Somehow, firefighters were able to prevent the blaze from reaching the buildings fronting King Street, but not before it consumed several kitchens, stables and outbuildings. Meanwhile, the back buildings and several houses fronting Royal Street were consumed, as was a frame house fronting an alley that was immediately south of Green's workshop.

Moving east, the fire reached Fairfax Street, where it threatened to demolish everything in sight. Edward Stabler's apothecary shop was

protected, thanks to a three-story fireproof. But everything else on the west side of Fairfax between the apothecary and Prince Street was almost simultaneously in flames. By now the effort to contain the fire had grown in manpower, but efforts were fruitless from stopping the fire from crossing the street and consuming two three-story brick houses.

Apparently, some shingles were still smoldering when a great wind blew from the northwest, carrying them four hundred feet toward the intersection of Water and Prince. The *Alexandria Gazette* described it as "another, and still more awful fire." Within a few minutes, both sides of Prince Street were on fire. Every house but two was destroyed, many of them with their whole contents incinerated.

At this point, the situation seemed grim. Exhausted firefighters had been working for hours to contain the situation, only to have the fire grow out of control. Hope and exertion yielded to apathy and despair. Fortunately, this was when help arrived from Washington and Georgetown. Thousands of fresh recruits came to the aid of the weary Alexandrians, reanimating drooping spirits and redoubling their efforts. Horse-drawn carriages arrived from Capitol Hill, the Post Office Department and the First and Second Wards from Georgetown and the Marine Station.

All of the toll gates to all of the bridges were thrown open, and both houses of Congress adjourned. Among the volunteers who arrived on the scene was a man by the name of James Barbour, a former governor of Virginia who was currently serving as secretary of war in the John Quincy Adams administration. Another Washington luminary there was a man by the name of Samuel Price Carson, a Jacksonian Democrat who represented North Carolina's Twelfth District in the House of Representatives. Members of a traveling circus that was in town also took part in the fight, performing heroic feats of daredevil theatrics to extinguish the flames.

The arrival of reinforcements represented a dramatic turning point, one that was chronicled by a writer using the name "A Traveler" in the *National Intelligencer*. "Washington was there in strength," explained the Traveler, "and by the uncommon zeal and exertions of both towns, the fire which threatened destruction to the whole town, and to the shipping in port, was providentially arrested in its progress, after consuming perhaps about fifty houses and a large amount of property."

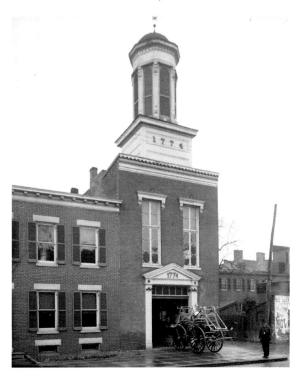

The Friendship Fire Company was founded in 1774, although this building was constructed in 1855. *Library of Congress.*

At the high point of crisis, one of the circus performers by the name of Samuel Shrock mounted the highest and steepest roof in town. According to the Traveler, everybody else seemed to think that this was an impossible task. But Shrock sustained himself by a shallow gutter within a few inches of the eaves. From this perch, he was able to receive water from a dormer window and apply it to the fire. The Traveler noted that this act of heroism was able to save that particular house and prevent the fire from crossing the street and moving toward the river, saving an untold number of other houses from certain destruction.

"It was almost worth a fire to see so much generous feeling on one hand, and so many kind of thankful looks and expressions on the other," the Traveler wrote. "Every house was thrown open, every table was free, every heart was warm, and [a] lovely woman was first in shewing what she felt."

When the smoke cleared, it was evident that the devastation was unimaginable. Even the venerable press of the *Gazette* had been silenced temporarily. It wasn't until five days after the fire that the newspaper was

able to start production again, apologizing to readers for the "derangement consequent upon the removal of our Printing Establishment."

"Language cannot paint so distressing a picture, nor will those who did not see the original, ever be able to equal it in their imagination," reported the *Gazette* when it was able to resume publication. "Human ability seemed to be utterly inadequate to the task imposed upon it, and the allied elements of destruction marched over us in all their mighty strength and grandeur, prostrating every obstacle thrown in their way, and scattering desolation in every direction."

The fire lasted five hours that frigid January day, with the flames rushing from house to house with increasing fury. Furniture and goods were scattered in every direction. Women and children scrambled for safe places to escape the growing inferno. At certain points in the fire, at least a dozen houses were on fire at once. If it hadn't been for the legion of helpers from Washington and Georgetown, Alexandria could have been erased from the map forever. The *Gazette* estimated damages at $150,000.

"There is not one whose heart does not swell with gratitude to his deliverers, and who is not filled with admiration of their disinterested philanthropy, and more than brotherly affection," the *Gazette* explained. "We owe them a debt which words cannot acknowledge, and which, we trust in God, we shall never have an opportunity to pay in kind, but it is indelibly recorded in our memories."

The fire left many homeless during the coldest month of the year. The wealthy were reduced to begging for food as sorrow and despair became the order of the day. Many lost everything they had in the destruction, which vaporized their financial status and rendered them paupers. In the smoky ruins of the fire, bleary-eyed Alexandrians wandered the streets in search of charity with a jaundiced eye toward the future.

"I saw them all, and it was a sad, a sickening, a melancholy sight," the Traveler wrote. "It would be a vain attempt of me to give a description of the grief and misery of the scene."

In the aftermath of the fire, Alexandria struggled to account for all of the property that had been lost that day. Part of the problem was the mass confusion created by such a universal tragedy. The situation was so

One of the many fire insurance plaques that can be found in Old Town. *Brandy Crist-Travers.*

perilous that Mayor John Roberts took out an advertisement in the *Gazette* to address the widespread looting that was taking place, announcing that he would be at his office to receive all of the goods, furniture, books and weaving apparel that "may have fallen into the hands of persons to whom they do not belong." He added: "We do not hesitate to say that if we find any part of our property in strange hands after today, the explanation must be very clear, or it will not be satisfactory."

The Great Fire of 1827 also sparked a political fight in the halls of Congress, one that led to a duel leaving a former congressman dead at the hands of a sitting congressman. The city clearly needed disaster relief, and people were feeling generous. Georgetown voted for $500 for relief, and the city council of Washington voted to send $1,000. Meanwhile, Congress was debating a bill that would appropriate $20,000, a huge sum of money in those days. Some opposed the resolution as a dangerous precedent.

"Why may we not compensate the territories of Florida and Michigan and Arkansas for the ravages of the Indians?" asked Andrew Stevenson, a Jacksonian Democrat who represented Virginia's Ninth Congressional

District. "Why not exhaust the treasury of the nation upon the objects of charity?"

Samuel Price Carson, one of the many congressmen who had hurried across the Potomac the previous day to fight the disastrous fire, leapt to his feet to defend the resolution. "Do not all the territories have delegates to represent their wishes? But the people of the District have none to represent them but representatives at large," Carson said. "The latter, therefore, have the strongest claim upon the care and liberality of the House."

Francis Johnson, an anti-Jacksonian who represented the Tenth District of Kentucky, pointed out that the United States Constitution limited the scope of federal appropriation to public purposes such as forts and roads.

"If the Congress has the right to give away public money for charitable purposes," he said, "there is no limit in the Constitution to whom or to where it shall go."

The debate stretched into the afternoon of January 19 as congressmen went back and forth over the wisdom of appropriating money to Alexandria, D.C. Finally, after the question had been called, the House passed the measure by a vote of 109 to 67. Four days later, the Senate passed it by a vote of 27 to 17, sending it to President John Quincy Adams, who promptly signed it. Shortly afterward, a draft for $20,000 was sent to Alexandria Mayor John Roberts.

The issue was resolved, but the politics weren't over. At the close of the Nineteenth Congress, Carson returned to North Carolina to run for reelection. But he had competition. Dr. Robert Vance, a longtime friend and former member of Congress, decided to run against Carson and make an issue of the fire relief sent to Alexandria. Vance had served only one term in the House of Representatives, but he agreed to step aside when party leaders wanted to send Carson instead. Apparently, Vance suffered from a crippling childhood disease that stunted his growth and left him with a twisted leg, and party leaders thought that the handsome Carson would make a better representative. The tension was palpable at the first debate, shortly after Carson finished his opening remarks.

"I note that my competitor was careful not to mention that he voted away $20,000 of the people's money to the city of Alexandria," Vance explained.

"If my competitor has been in my place, he would have done as I did," Carson responded. "For I know he has heart." The crowd burst into applause, but Vance was having none of it. He rose to his feet, quieted the applause and renewed his line of attack.

"If you can admire, as some of you seem to, a prompter who sends a man's benevolent hand into some other man's pocket than his own," Vance explained, "all I can say is—I can't." Carson reminded the audience that Vance has supported a $250,000 appropriation to pay for Marquis de Lafayette's grand tour of America in 1824 and 1825. Vance again leapt to his feet to defend himself.

"That demagogue who objects to my vote in favor of the Lafayette appropriation, I don't envy him his feelings," Vance said, "and I don't see how any gentleman could."

"Doctor Vance," replied Carson, "if you were not such a diminutive dwarf, I would bring you to account for your vile utterance."

"You are a coward and fear to do it," Vance shot back.

What started as a high-minded Congressional debate had now descended into personal insults and name-calling. The meeting ended, but both men knew that the epithets flung at each other were not the kind of things to be taken lightly. Things got even worse as Election Day approached, and Vance accused Carson's father of taking British protection during the Revolution. Carson won the election and then challenged Vance to a duel.

The congressman and the former congressman met each other on a crisp, clear November morning at Saluda Gap between North and South Carolina. As their associates paced off positions, Carson was heard explaining that his plan was to simply graze Vance. But Carson's friends persuaded him this was ill-advised because the former congressman would only demand another chance at killing him.

The principals took their positions. At the command, Carson fired but Vance hesitated. Accounts vary as to what happened next. Some say that Carson's bullet struck Vance before he could return fire. Others say that Vance fired but only nicked Carson's belt. Whatever happened, Vance was mortally wounded in the exchange. Carson rushed toward his opponent but was held back from friends who were participating

in the duel. "Poor Sam," he whispered. "I don't have the first unkind feeling for him."

That day haunted Carson for the rest of his life. According to one account, he confessed to a friend years later that the "beloved face" of the man he killed was never far from his thoughts. So Carson served out his term and then returned to private life in North Carolina. He later served a term in the North Carolina legislature before moving to Texas, where he became the first secretary of state for the republic.

THE CODE DUELLO

Satisfaction in Alexandria, D.C.

It was known as the Code or, perhaps more elegantly, the Code Duello. At the dawn of the nineteenth century, dueling had become, in the words of Parson Weems, a "mania" that was gripping the young nation. In a little-known 1820 manuscript tucked away in an obscure corner of the Library of Congress, Weems castigates the phenomenon as "a fit of madness" engaged in by men who led "a foolish and disorderly life, terminating as it everlastingly does, in misery."

Oftentimes, an intense foreplay preceded the duel—one that frequently spilled out on the pages of the newspaper. And the *Alexandria Gazette* was no exception, printing accusations and counteraccusations in the parry and riposte by those who Weems described as "the bloody minded and distempered beasts who are always picking quarrels and writing challenges." The telltale signs were "the scornful nose, the supercilious brow and the bold impudent loquacity."

"Call it chagrin, call it hate, malice, revenge, or by whatever name you please, it is misery still, that puts men up to dueling," Weems wrote. "If they can't muster patience to wait long enough to kill themselves with whiskey and tobacco, they will give way to their brutish passions and provoke some other madman to blow out their brains."

"Scene in Washington" shows how the capital had become gripped by dueling mania in the 1830s. *Library of Congress.*

And yet it was men of means who participated in the mania, casting the barbaric practice as a gentleman's game. That's certainly how it appeared for John Mason McCarty and Armistead Thomson, who participated in an infamous duel in 1819. Both men had been raised on the plantations of Virginia's landed gentry, the "web of kinship" that constituted the commonwealth preceding the formation of the District of Columbia. They were even second cousins, and each was descended from the blue-blood Tidewater aristocracy that had a death grip on power at the time. One of them was the grandson of George Mason, while the other was his grandnephew.

McCarty's mother was the daughter of the famous statesman, who was one of the few members of the Constitutional Convention who refused to sign. In about 1815, McCarty decided to move to Leesburg and supervise land that he had inherited from his famous family. Armistead Mason was the grandson of George Mason's older brother, Thomas

Mason. Not only were McCarty and Mason related by blood, they were also related by marriage. McCarty's brother, William, married Mason's sister, Emily, in 1816.

But this was a family tree that bore bitter fruit. Despite being tied by blood and marriage, these two men were polar opposites, politically speaking.

McCarty earned the nickname "the Fire-eater" as an ardent Federalist. Dashing, witty and handsome, he had a rapier wit and physical agility. But he also had somewhat of a impetuous nature, someone who had a short temper and was physically combative when challenged.

Then there was the high-strung Mason, who was described as sensitive, brooding and arrogant—a man who had distinguished himself as a brigadier general during the defense of Norfolk in the War of 1812. Like his cousin, he was handsome, wealthy and quick to anger. But unlike his cousin, he was an ardent Republican.

When William Giles announced his resignation from the Senate in 1816, the young General Mason saw an opportunity. Sure enough, the state legislature appointed him to fill the unexpired term left by Giles; he became the youngest person to ever serve in the United States Senate. But Mason wanted his own path to power and resigned the Senate seat to launch his own campaign for the United States House of Representatives.

His opponent in that race was Federalist Charles Fenton Mercer, also a cousin in the "web of kinship" that dominated Virginia in those days. At thirty-eight, Mercer was the oldest and least bombastic of the cousins. After graduating first in his class from Princeton in 1797, Mercer launched a successful legal career before serving as a brigadier general in the War of 1812. Brilliant and exceedingly popular, he later became a leading figure in the Virginia General Assembly.

The 1816 campaign for Northern Virginia's House seat ended up being one of the most rancorous ever conducted in American politics. Part of that was the importance of the district, which stretched from Fairfax and Loudoun into Fauquier. Yet perhaps more significant to the intensity of the race was the reputation of the men involved and the hotheaded nature of the partisans on either side. The campaigning was marked by bombastic rhetoric, vicious quarrels and threats of violence.

When all was said and done, Mason lost the election. He spent the next year sizzling with indignation, launching a series of arguments and disputes about what had happened in the race. Refusing to accept defeat, Mason insisted that the votes be examined for discrepancies. One by one, voters were scrutinized until Mason's attention fell on one Jack McCarty. Mason insisted that McCarty was simply too young to vote.

Congress convened a Committee of Elections to review the votes, and members launched an exhaustive investigation. Meanwhile, the general and the "Fire-eater" began exchanging mutually insulting letters. By November 1817, the feud had erupted into a full-scale war as Mason challenged Mercer to a duel, which Mercer declined on account of religious convictions against dueling. That's when Mason turned his fire on McCarty and continued the wild and impetuous attack against his younger cousin. Unlike Mercer, McCarty was all too eager to fight back.

By the spring of 1817, the feud had spiraled into yet another election. This time, Mason demanded that McCarty take an oath that he was of eligible age to vote and hold office. McCarty took the bait. A few days later, before an audience of one hundred at a Virginia courthouse, Mason called McCarty a "perjured scoundrel." McCarty responded by lashing out against what he called the "bullying and dictatorial" tactics of his enemy. "I instantly applied to him such epithets and such language as it at once induced every man present to believe that I would be challenged," McCarty would later explain. "Instead of challenging me as expected, he, to the astonishment of all, expressed himself satisfied with his childish retorts and the subject lay dormant for many months."

But this sleeping giant refused to slumber for long. On November 8, 1817, Mason wrote a letter to McCarty asking him to contradict an assertion in a recently published newspaper article that Mason was a coward. McCarty replied that he had never sanctioned the article and gave Mason permission to publish his reply. Mason responded by publishing the reply along with his own commentary, which implied that McCarty had completely exonerated him of wrongdoing. It was all downhill after that. McCarty was infuriated with Mason's duplicity. So the cousins exchanged increasingly hostile letters to each other, escalating the war of words into a pitched battle.

Mason accused McCarty of being a "shakebag of the federal party," an "ass in lion's clothing" and, perhaps most pointedly, a "coward scoundrel." Afraid to do his own fighting, Mason said, McCarty brought in a public brawler "from the back alleys of Alexandria" to do his dirty work, and "although he is always ready to box, bite and gouge with any blackguard in the street, he shrinks instinctively from honorable combat."

McCarty was not one to shrink from a fight, calling his rival a "disgraced coward." Describing Mason's brief career in the Senate as "that paucity of talent which rendered him so conspicuously dumb in the senate of the United States," McCarty suggested that "in making known his determination to leave the senate, he honestly implied that his dearth of brains had induced that determination."

Meanwhile, the Committee of Elections finally concluded its investigation in January 1818, rendering a final decision in the long-disputed election of 1816: Mercer was the duly elected representative, and McCarty's vote was "pure as any on the poll." Needless to say, this did not end the quarrel, and on May 15, 1818, McCarty challenged Mason to meet him in a duel at a distance of three feet. Mason offered a counterproposal, suggesting that he would accept a challenge of the "usual kind" on "equal and honorable terms," although he hedged the offer with reservations about losing his military commission in the process. McCarty did not want to engage in a duel of the "usual kind" because that was illegal in Virginia, and he could be hanged if Mason died.

"With this preponderance of State favor in his behalf, what I ask would be my fate if I were to fight an ordinary duel with Gen. Mason and survive him?" McCarty asked. "'If I did not voluntarily offer myself to the officers of justice, I should by them be hunted down, dragged to a loathsome jail, loaded with manacles and foot chains, and finally doomed to die on the gallows."

By the summer of 1818, McCarty and Mason were ready to stand down. Each presumably went back to private life—Mason at a plantation home known as Selma and McCarty at an estate called Coton. But the truce did not last long. By January 1819, the conflict had entered its last and most dramatic stage. Mason resigned his commission, freeing him from the restraints imposed by the commonwealth of Virginia against

dueling. Then he wrote a last will and testament, followed by a challenge to McCarty.

"Agree to any terms that he may propose, and to any distance—to three feet, his pretended favorite distance—or to three inches, should his impetuous and rash courage prefer it," Mason wrote to his seconds. "To any species of fire-arms—pistols, musket or rifles—agree at once."

McCarty agreed to fight, but he was still hoping to avoid a duel of the "usual kind." So he suggested the two leap together from the dome of the Capitol in the District of Columbia. That idea was rejected. The next offer was to "fight on a barrel of powder." That was followed by a proposal that the two engage in hand-to-hand combat with dirks. All of these were rejected. Finally, a much more traditional challenge was issued. The weapon of choice would be muskets loaded with buckshot. The distance would be twelve feet. Parties would meet at the infamous dueling grounds across the Potomac River in Bladensburg, Maryland.

The duel was set for Saturday, February 6, 1819. A snowstorm was sweeping through the path along the brook. McCarty faced up the brook. Mason faced down. They were so close that eyewitnesses said they appeared to almost touch each other. Mason was dressed in a large overcoat, while McCarty stripped down to a shirt so that he could roll up his sleeves for better use of his arms.

The signal was given. As Mason was raising his musket to fire, the firearm caught in the skirt of his long overcoat. The accident flustered his aim, although McCarty's arm was unfettered. The result was a duel that came down to fashion. When the smoke from the muskets cleared the brook, Armistead Mason was dead. Bushes were splattered with blood, and fragments of flesh were scattered throughout the brook. John McCarty survived, although he was severely wounded in the arm.

Later that day, McCarty appeared in Alexandria, D.C., making a very public show of his victory against his despised foe. Needless to say, this created quite a sensation, especially since rumors were already swirling through the region about what had happened that morning. One of the rumors was that Mason had been struck with three musket balls, although a postmortem examination found that McCarty's ball had actually split into three parts.

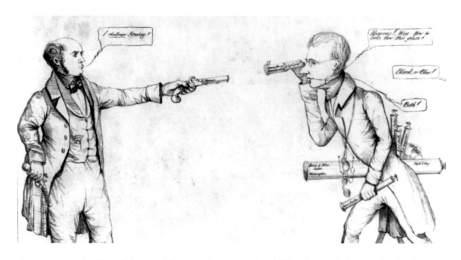

"Symptoms of a Duel" depicts Treasury Secretary Levi Woodbury aiming a pistol at James Harlan, a bespectacled man scrutinizing him through a telescope labeled "Committee of Investigation." *Library of Congress.*

Mason's wife was heartbroken about the duel, refusing to speak about it and taking pains to be buried at Congressional Cemetery in the District of Columbia rather than beside her late husband in Leesburg. McCarty never lost his taste for politics and was elected to serve a term in the House of Delegates in 1834. For good or ill, both men upheld the Code.

One of the most infamous duels in Alexandria was sparked at Gadsby's Tavern, a famous watering hole where George Washington and Thomas Jefferson famously partied in an earlier generation. As the social center of the city for many years, the tavern also hosted many famous men of means, as well as their egos. Take, for example, Captain James McGuire and Colonel Adam Lynn. Both served tours of duty in the War of 1812, and both seemed to have maintained a sense of honor at any cost.

After the war, McGuire became a house joiner and Lynn became a silversmith. Yet there would be no era of good feelings between these two. A vicious blood feud between them had apparently been brewing for years. Court records show an 1822 case in which federal prosecutors went after Lynn for sending a challenge to McGuire to fight in a duel. McGuire was also indicted for accepting the challenge. When their day in court arrived, McGuire was called to the stand and asked whether such a written challenge was in existence.

McGuire lawyers jumped to their feet and objected on the grounds that the answer to that question might be incriminating. The court agreed, and McGuire was not forced to answer the question. That meant that prosecutors had no evidence, and the case fell apart. But apparently the animosity between these two only continued to fester.

Three years later, in 1825, the two were at it again. A *National Intelligencer* report explained that the inevitable duel between the two was the culmination of "difficulty which has for some days existed between Capt. McGuire and Col. Lynn." When the day arrived, the participants arrived at nearby Oxon Hill, directly across the river from Alexandria, D.C. Each man brought his own physician to the firefight.

Lynn won the opportunity to choose positions, selecting to face the west. That left McGuire to face the east and its sunrise, which would be happening momentarily. At forty yards, they readied their double-barreled shotguns. Several friends and an Alexandria police constable by the name of Slatford had gathered to witness the event. Just as McGuire took aim, the sun rose and created a glare. McGuire fired, although the ball went wild and struck a fence rail where the constable was sitting four hundred yards away.

Slatford, "feeling personally injured" according to the *Intelligencer*, moved to gully beneath a bank, "with his head partly exposed above the bank." McGuire took aim once again, but this time the glare sent his shot into the dirt, throwing dust into Slatford's eyes. Slatford moved to the bank and decided to take his chances witnessing one more round "boldly standing on the bank, though not without forebodings of evil" according to the newspaper.

"The sight was long one to be remembered," Slatford would later recall. Here were two of Alexandria's most distinguished war heroes, using the Code to gain satisfaction. In the heady romantic gauze of the era, it was an exercise in gallantry and reputation to repair "wounded honor." Once again, the parties were ready to engage. And so the command was given. This time, Lynn took aim and fired a shot that went so near the constable that he swore it "singed the hair of his wig." McGuire demanded another round, but Slatford threatened to arrest them because he believed that they were deliberately firing at him.

Henry Clay. *Library of Congress.*

"This ended the duel," the *Intelligencer* reported, "neither of the principals having been injured."

Alexandria's most famous duel took place in 1826 with two heavyweights in American politics: Secretary of State Henry Clay and United States Senator John Randolph of Roanoke. The feud between these two was legendary. According to one story, Clay once met Randolph on a sidewalk. The cranky old Virginian moved toward the center of the sidewalk and announced, "I never turn out for scoundrels."

"I always do," responded Clay, stepping aside with mock politeness.

Unlike other major duels of the day, this one actually took place in Alexandria, D.C., at the request of Randolph. The dispute was sparked in 1824 when Clay threw his support in the House of Representatives to John Quincy Adams and ended up with a gig as secretary of state—an arrangement that many considered a "corrupt bargain." Randolph blasted

the alliance in a March 30, 1826 speech on the Senate floor, disparaging the deal "between old Massachusetts and Kentucky; between the frost of January and young, blithe, buxom and blooming May."

Senator Randolph then compared Adams and Clay to two unsavory characters in Henry Fielding's popular novel *Tom Jones* by castigating "the coalition of Blifil and Black George…the combination unheard of till then of the Puritan with the blackleg."

Clay resented being called a blackleg, which was an epithet intended to portray the secretary of state as a crooked gambler. Soon afterward, Clay challenged Randolph to a duel. Mutual friends of both parties tried to intervene and smooth things over, but it was to no avail.

Saturday, April 8, 1826, was chosen as the date. Randolph wanted the duel to take place in Virginia because if he was killed, he said, he wanted to fall on the soil "endeared to him by every tie of devoted loyalty and affection." So the participants agreed on a spot in a dense forest on the Virginia side of the Potomac just above the Little Falls Bridge—today the location of the Chain Bridge.

Pistols were chosen as the weapon on choice. Half past 4:00 p.m. was chosen as the time. The distance would be ten paces, and each party would be attended by two seconds and a surgeon. No practice rounds would be allowed. These gentlemen were playing for keeps. Clay's seconds were General Thomas Jessup and Senator Josiah Johnston of Louisiana. Randolph's seconds were Colonel Edward Tattnal of Georgia and General James Hamilton of South Carolina.

The night before the duel, Randolph paid a visit to General Hamilton to chat about the duel. The senator seemed incredibly relaxed for a man who would be facing the business end of a pistol the next morning at ten paces.

"Hamilton, I have determined to receive, without returning, Clay's fire; nothing shall induce me to harm a hair of his head," Randolph told Hamilton. "I will not make his wife a widow, or his children orphans. Their tears would be shed over his grave, but when the sod of Virginia rests on my bosom, there is not in the wide world one individual to pay this tribute upon mine."

Randolph's friends thought this plan was insane and tried to talk him out of it. But the senator was stubborn, and he had already charted his

John Randolph. *Library of Congress.*

course for the duel. Their attempts were in vain. "If I see the devil in Clay's eye," Randolph allowed, "I may change my mind."

On the day of the duel, participants arrived at the appointed time and place, near the modern-day intersection of Military Road and Glebe Road. The sun was setting, and Randolph apparently found no devil in Clay's eye. Yet he was confronting a man who possessed a fearless and vigilant purposefulness of mind. Here were two giants of American politics, facing each other on the field of battle. The ground was marked off for the duel, and the principals saluted each other courteously. Each took his respective place on an east–west line. Clay was in front of a small stump, while Randolph was near a low gravelly embankment. Colonel Tattnal handed Randolph his pistol and sprung the hair-trigger.

"Tattnal, although I am one of the best shots in Virginia, with either a pistol or a gun, yet I never fire with a hair-trigger," Randolph said.

"Besides, I have a thick buckskin glove on which will destroy the delicacy of my touch, and the trigger may fly before I know where I am."

But the colonel insisted. When the secretary and the senator took their positions, Randolph's pistol went off before the word was given. Fortunately, the muzzle was down. Colonel Jessup said that he would leave the field if that happened again, even though Clay said it was clearly an accident. Randolph was handed another pistol. Then both principals exchanged shots. Randolph's bullet struck a stump behind Clay, and Clay's shot kicked up a bit of earth and gravel behind Randolph. Each side reloaded, and Clay fired a shot that knocked up gravel behind Randolph. Then Randolph raised his pistol and fired into the air. "I do not fire at you, Mister Clay," the senator said.

With that, the senator approached the secretary of state across the dueling field and extended his hand. The secretary responded enthusiastically, and the two men shook hands. Even though Randolph's coat had been pierced by one of Clay's shots, the feud had obviously come to an end.

"You owe me a coat, Mister Clay," Randolph said.

"I am glad the debt is no greater," Clay responded.

CAPITAL OF SLAVERY

Alexandria's Peculiar Institution

S lavery was part of the earliest days in Alexandria, and it was a major reason that Alexandria drifted apart from the District of Columbia.

From its earliest days as a port city, the peculiar institution was at the heart of the tobacco economy that filled its warehouses and stocked its markets. Although the plantation estates in Fairfax County used slaves to work the fields, Alexandria slave owners lived in houses alongside their chattel property. Living that close created a sense of uneasiness, prompting a sense that lines must be clearly drawn.

Before the Revolutionary War, an uprising of slaves against their masters in Fairfax County shocked the community. After it had been summarily quelled, the heads of the slaves were suspended on spikes over the Alexandria jail—a gruesome message to any slave who was considering insurrection.

After the Revolutionary War, it became increasingly popular for slave owners to free their slaves upon the owners' deaths. That created a rapidly expanding population of free blacks in Alexandria. Census records show that the slave population increased by 250 percent between 1790 and 1830, and the free black population swelled by an astonishing 2,300 percent during that period.

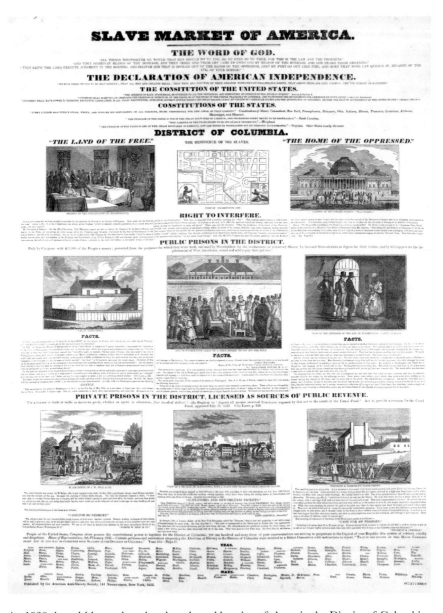

An 1830s broadside condemning the sale and keeping of slaves in the District of Columbia. *Library of Congress.*

The "peculiar institution," as slavery was known in those days, carried a fair amount of moral ambiguity. This was a time, after all, when humans were bought and sold as chattel property. As a result, drawing the line

between right and wrong sometimes carried a sense of frontier justice. Consider the 1791 case of Moses, an educated slave whose ability to read and write landed him a spot as overseer on his master's plantation. It was a sort of ideal existence for a slave, one in which he became a valued member of the working plantation.

Then everything changed. As was the case in those days, Moses changed hands. The exact reasons remain unclear. It could have been a result of the death of his owner. Or perhaps trying times forced an economic moment of truth. Then again, maybe there was no reason. With the future of human lives at stake, little more reason was needed in those days other than impulse and power. Whatever circumstances forced Moses into the dominion of a new owner, they conspired against his interests.

His new owner had an overseer who was a cruel tyrant by the name of Hezekiah Williams, a man who literally beat his brother to death and shackled Moses in chains for days at a time. One day, Moses was having difficulty walking back to the overseer's house, where he would be chained up for the evening, because of the iron spancles. So he asked one of his fellow slaves to give him a seat in the cart. For whatever reason, or perhaps for no reason at all, that sent the overseer into a fit of rage such that he threatened to give Moses the same treatment he gave his late brother. That may have been the biggest mistake Williams ever made.

That evening, when the cruel overseer was asleep, Moses disengaged himself from his handcuffs and freed himself from the staple holding him to the wall. Taking the overseer's gun, Moses escaped as quietly as he could. But the spancles prevented him from going very far before his brutal overseer awakened and confronted the escaping slave with three vicious dogs. Apparently, Moses cautioned his pursuer to stand off. Explaining that he had a loaded firearm, the escaping slave said that he was willing to shoot if the situation warranted it. Well, the situation warranted it. And Moses plugged the savage overseer. "Sir, the overseer would have killed me had I not killed him," Moses told his owner that evening.

By the time the trial began in Alexandria, the courthouse proceeding took on the form of an exorcism. The cruelty of this particular overseer was apparently well known, and the popular will in the case seemed

to take the form of warning against senseless cruelty that plagued the peculiar institution. Witness after witness who came to the courthouse, which was located on the same block where the Alexandria City Hall now stands, testified that Moses was an honest, faithful slave. During his time as overseer under his previous master, he had been entrusted with the sale of corn and other articles. Never had there been so much as a cross word.

Moses was acquitted in a split decision of the Fairfax County Court, acknowledging the line of defense that a master's authority over his slave was limited. The verdict sparked a lively debate on the pages of the *Alexandria Gazette* and illustrated the murky ethics of slavery in Alexandria, D.C. Free blacks became wage-earning members of the community and began forming their own neighborhood, which was known as "the Bottoms," located on the outskirts of town in marshy vacant land. In later years, "the Hill" was another semiperipheral area populated by free blacks. This was a time when planters switched from tobacco to grain, and fewer and fewer slaves were needed for production. Yet when the African slave trade was outlawed in 1808, the District of Columbia suddenly became a major player in the industry of human bondage.

"Scarcely a week passes without some of these wretched creatures being driven through out streets," reported the *Alexandria Gazette* in 1827. "After having been confined, and sometimes manacled in a loathsome prison, they are turned out in public view to take their departure for the South. The children and some of the women are generally crowded into a cart or wagon, while others follow on foot, unfrequently handcuffed and chained together."

Cotton planters in the Deep South could no longer get field hands directly from Africa. So they turned to the capital of slavery, Alexandria. This was a time when commerce was directly tied to transportation. And it's no accident that the first toll road created in the new nation connected Alexandria to Snicker's Gap in Loudoun County. Residents and businessmen relied on this road to facilitate communication between the wharves and docks in Alexandria and the rich farmlands in Fairfax and Loudoun. This new road became known as Little River Turnpike, except the section in Alexandria, which was known by its colonial name— Duke Street.

Here is where we find Franklin and Armfield, a new business that set up shop in 1828 at 1315 Duke Street. The building had previously been the home of Robert Young, a prominent member of Alexandria society who served as a brigadier general in the War of 1812 before serving as president of the Mechanics' Bank of Alexandria. Now it became a nexus of the slave trade, partly a function of its location along the major commercial thoroughfare in and out of town.

The neighborhood had a milling business at Cameron Mills, a distillery, potters, tanneries, a glass factory and other industries. It was a center of business and commerce for the region. Established in 1828 by Isaac Franklin and John Armfield, the newly formed company announced itself to the community in a May 17, 1828 advertisement in the *Alexandria Gazette*:

> *The subscribers having leased for a term of years the large three-story brick house on Duke Street in the town of Alexandria, D.C., formerly occupied by Gen. Young, we wish to purchase one hundred and fifty likely young negroes of both sexes between the ages of 8 and 25 years. Persons who wish to sell will do well to give us a call, as we are determined to give more than any other purchasers that are market, or that may hereafter come into market.*

Early in the nineteenth century, southern planter Isaac Franklin realized that substantial profits could be made in the slave-trading business. He began selling slaves at Natchez, Mississippi, as early as 1819. In 1824, he met John Armfield, who became a nephew by marriage. The two became business partners four years later and launched a slave-trading empire in Alexandria. Armfield developed a reputation as an upstanding businessman in a dastardly trade. He would eventually become the largest slave dealer in Virginia and Maryland.

"Armfield was neither an enlightened humanitarian nor a barbarian," explained historian Donald Sweig in a 1980 speech at the Lyceum. "I supposed you could say he was the best of a bad breed."

Armfield would ship slaves to Natchez, where Franklin oversaw the Mississippi side of the operation. The business headquarters on Duke

Street was an ideal location because it had access to good roads and the ability to move slaves by land or water with the added benefit of having an elegant showplace for the human wares. It was from this location that Armfield shipped thousands of slaves south to Natchez and New Orleans, making both men millionaires in the process.

But they didn't rake in all of that blood money without opposition. Because of Alexandria's proximity to Washington, abolitionists would arrive on the scene to lobby against Armfield's business. Sometimes they would show up at the slave-trading office itself. One contemporaneous account of the building described it as "a handsome three-story brick house, very handsomely painted with green blinds.

"We were ushered into a well-furnished room and invited to take some wine," wrote one visitor in 1834, "some bottles of which were standing on the side-board, for the accommodation, doubtless, of purchasers."

Passing through the house, visitors walked into a yard where the slaves were located. The yard was surrounded by a high whitewashed wall, with fifty or sixty male slaves located to the west side of the block near Alfred Street. About thirty or forty women and children were kept on the east side of the block near Payne Street, and the two areas were separated by "a strong grated door of iron." One visitor described the door as "doubly locked and strongly secured." One visiting abolitionist had heard of a dungeon, where "refractory" slaves were given the thumbscrews.

"It was not to be expected that I should be allowed to visit such a place," he wrote. "To deny the existence of which would be the natural consequence of having it."

Each yard was a paved square, about forty feet wide and fifty feet long. Half the yard was covered with a roof, while the other half was exposed to the open air, with a water pump that was located in the center. Under the roof, a long table was set with tin plates where the slaves would eat boiled meat and bread. A kitchen and hospital were located on the east side of the square, and slaves slept in the cellar with an entrance that was locked by "a strong iron-grated door."

The compound had several buildings, including a tailor's shop, where new clothing was readied for the slaves to wear during their long journey south. The males were outfitted with two suits, and the female wardrobe

was of "considerable taste," according to another contemporaneous account. A hospital building was part of the complex, as was a building outfitting slaves for their overland shipment south. Slaves who worked in the kitchen were trusted "to go at large in the town." But because 3 or 4 white men were in charge of 150 slaves, they were often chained at night.

Most of the slaves were sent overland in a train of wagons to Natchez, chained together in pairs to prevent their escape. When they camped in tents at night along the way, the guards were well armed. The slave dealers also owned a ship, called the *Tribute*, which could carry eighty female and one hundred male slaves. The ship would sail from Alexandria to New Orleans, where the slaves would be marched overland to Natchez.

During the initial years of business, Franklin and Armfield faced stiff competition from dealers in Baltimore, Richmond and Norfolk. But after a while, the slave-dealing pair were able to best their rivals in Georgetown and Washington, capturing almost half of the coastal

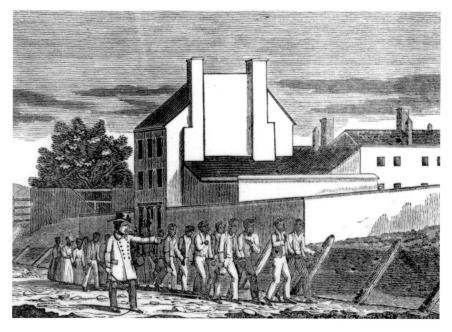

A depiction of the Franklin and Armfield slave trading operation in Alexandria from a Quaker broadside criticizing the peculiar institution in the District of Columbia. *Library of Congress.*

slave trade from Virginia and Maryland to New Orleans. By 1836, the business had become so prominent that it was featured in an antislavery broadside. As the newspaper advertisements indicated, the slave trade was a cutthroat business.

As the business grew, it scattered agents throughout the region, including R.C. Ballard & Co. in Richmond, J.M. Saunders & Co. in Warrenton and George Kephart in Baltimore, Rockville and Fredericktown, Maryland. James Franklin Purvis conducted business for the company in Frederick, Maryland, and Isaac Franklin's own nephew, Thomas Jones, acted as the company's agent in Easton, Maryland. After a while, the *Tribute* was not enough to carry all the slaves. So the business added ships known as the *Uncas* and the *Isaac Franklin*.

Armfield was so successful that he was able to build one of the finest houses on Prince Street, a house in the 1000 block that was described by one observer to be the most magnificent in town. And that wasn't his only house in town. Apparently, he began buying properties all over the city as he continued to direct the slave wholesale operation on Duke Street. Some have suggested that he had little to do with Alexandria residents, especially since his real estate investments were purchased from nonresidents or people associated with the slave trade. He worked and lived on the periphery of town rather than at its core, putting him outside the circle of power.

Franklin and Armfield's slave trade changed over the years. In the early days, about 5 percent of the slaves were under the age of ten. That practice ended in January 1829, when the Louisiana legislature banned the separate sale of children under the age of ten. But that didn't stop the Alexandria slave masters from separating husbands from wives, a feature of the peculiar institution particularly reprehensible to abolitionists.

According to Sweig's study of ship manifests, family groups accounted for only 7 percent of Armfield's trade in 1829. That had doubled to 14 percent by 1830 and then had doubled again to 34 percent by 1834. The changing statistics indicate that Armfield was responding to social pressures. It's possible that the business was also trying to protect the slaves from abolitionists, who became increasingly drawn to the Duke Street business.

"After 1823, it became better business to buy families," Sweig explained. "Armfield responded to market pressures and not out of a concern for the welfare of children."

Whatever his motivations, Armfield did not become the preeminent slave dealer in Virginia and Maryland by considering the welfare of his slaves first. At the same time, however, he was not marked by the same kind of cruelty that plagued others in the industry. Take, for example, the number of slaves packed onto each ship bound for New Orleans. While the subsequent owners of the Duke Street slave pen crammed up to four hundred slaves at a time into a ship, Armfield limited the cargos to three hundred. "If Armfield paid $500 for a slave, he'd want to take good care of him," said Sweig.

As the years continued, Louisiana passed more laws that made business difficult. Then came the Nat Turner rebellion in 1831, after which each slave had to be accompanied by an affidavit with the signature of two men attesting to the good character of the slave. Late in 1836, Armfield and Franklin sold the business. Franklin retired to a plantation in Tennessee.

Some have argued that the peculiar institution played a central role in dividing the District of Columbia, creating a fault line between

Interior of an Alexandria slave pen. *Library of Congress.*

abolitionists in Washington County and slave owners in Alexandria County. As *Washington Post* columnist John Kelly pointed out, white Alexandrians of the era would probably have denied that slavery had anything to do with the movement that ended in retrocession—returning Alexandria to the commonwealth of Virginia. But there's more to the story. "If you'd asked a black Alexandrian, he might have given you a different answer," Kelly wrote in a 2010 column on the issue.

As early as the 1830s, abolitionists were petitioning Congress to end slavery in Washington. The conversation because so intense that a gag rule prevented congressmen from even broaching the topic in the course of their duties. That didn't stop the national debate, of course, which became increasingly heated as the years dragged on. Some believe that slaveholding Alexandrians saw the writing on the wall—essentially that the abolitionists in Congress might not be able to end the slave trade nationally, but perhaps they would be able to accomplish their aims in the capital city. Even though the conversation never explicitly turned to slavery, the theory goes, it was a ghost haunting the conversation about retrocession. That would mean that all of the high-minded talk about the right to be represented in Congress and the importance of municipal investment was all just a smokescreen. "This was political subterfuge of a high order," A. Glenn Crothers told Kelly. "This is a hot topic…you try to slip it through."

By the late 1840s, when Alexandria and Arlington retroceded back to Virginia, Alexandria had three slave-trading firms. While the Deep South had a deficit of slaves, Alexandria had a surplus. That meant there was lots of money to be made by shipping slaves from Alexandria to New Orleans. It also meant that any potential threat to the business would be viewed suspiciously. For those who believe that slavery was a secret cause prompting retrocession, the lack of contemporaneous discussion isn't necessarily evidence to the contrary.

Perhaps the best arguments for this case are made in the wake of retrocession. Because Virginia state law forbade the education of blacks, all of the black schools in the city were closed after it was no longer part of the District of Columbia. And Congress did, in fact, end the slave trade in Washington in 1850. That left slaves in Alexandria to look across the river

The haunting stare of a slave girl, who was born when Alexandria was part of the District of Columbia. The city's exit helped facilitate the institution until the Civil War. *Library of Congress.*

in anticipation. Not long after retrocession in 1846, here's what two black residents wrote to a Boston abolitionist: "[The] poor colored people of this city…were standing in rows on either side of the Court House, and, as the votes were announced, every quarter of an hour, the suppressed wailings and lamentations of the people of color were constantly ascending to God for help and succor in this their hour of need."

The year Alexandria left the District of Columbia was the same year that John Armfield formally terminated his relationship with Alexandria, with an 1846 land deed showing that the slave-trading partners sold three properties on Duke Street to George Kephart. Armfield had already left

town several years before, moving to Tennessee and resuming the life of a planter. His business partnership with Isaac Franklin dissolved in 1841, and Armfield spent the remainder of his days trying to recover funds from cotton planters who bought slaves on credit and then became caught in a depression that began in 1837.

Kephart and Company established a business that became "the chief slave-dealing firm in that State, and perhaps anywhere along the border between Free and Slave States," according to one observer in 1865. The operation seems to have increased the scale of the operation considerably, transporting 1,500 to 2,000 slaves south each year. And Kephart became known for a sense of cruelty and indifference to human suffering.

"When it was reported he was about, they trembled," one observer wrote. "Every slave that tries to escape to a Free State was invariably sold if caught, and generally lodged in Kephart's shamble, and never suffered to return to the place from which he ran lest he should tell others the means of his escape."

Under Kephart's cruel watch, the Duke Street compound was crammed with three to four hundred slaves at a time. Essentially, Kephart was willing to double down on the peculiar institution and the blood money associated with human bondage. An 1841 advertisement in the *National Intelligencer* demonstrated that he wanted to make sure he cornered the same market his predecessor spent years building: "Negroes Wanted—Cash and the highest market prices will be paid for any number of likely young negroes of both sexes, (families and mechanics included)…All communications addressed to me at the old establishment of Armfield, Franklin & Co., west end of Duke Street, Alexandria, D.C., will meet with prompt attention."

One eyewitness account from 1842 described several young slaves dancing to a fiddle. Kephart wasn't around, but a middle-aged caretaker took the visitor through the house and into the courtyard, where about fifty slaves were kept in place with high walls and a grated iron door. Despite the levity of the slaves dancing to the fiddle, the visitor perceived a darker quality to what was happening at Alexandria's slave depot. "There were, on the other hand, others who seemed prey to a silent dejection," wrote the visitor.

One melancholy woman was there with nine children, the whole family having been sold away from the patriarch. Another among the forlorn was a woman who had run away from her master twelve years before. Time had not been kind, according to the eyewitness account. Although she began a new life as a free woman and even married a man, she was later discovered and dragged back into a life of slavery. She was sold along with her child and was on her way to New Orleans at the time—that is, unless her husband could raise the funds necessary to free her, which he was apparently attempting. "If he failed," the visitor noted, "they are lost…forever."

Kephart kept the business until after Alexandria left the District of Columbia and returned to the commonwealth of Virginia in 1846. After the importation of slaves for resale into the District of Columbia was prohibited in 1850, Kephart sold the business to Charles M. Price and John C. Cook. Land deed records show that the sale was finalized in 1858—just before the peculiar institution tore the fabric of America apart and the Union army occupied the city and forcibly freed the slaves. Cook left the business soon after, replaced by James Birch. Kephart's name remained linked with the business until the last days of the slave trade.

In the years following retrocession, abolitionists and proslavery voices would come to understand the full consequences of separating Alexandria from the District of Columbia. The New York publication *Morris's National Press* declared that "there is something painful in this act of retrocession," and the *Boston Recorder* editorialized that "considerations should have prevented the passage of the law." When the Compromise of 1850 was being debated in Congress, Senator Henry Clay argued that southerners would have no objection to ending the slave trade in Washington "now that a large portion of the District has been retroceded to Virginia" and because no "motive or reason" remained "for concentrating slaves" in the district.

"Indeed, in response to Alexandria's retrocession and the 1850 compromise ban of the slave trade, a number of Washington slave traders moved their operations across the river," wrote Crothers in a 2011 essay. "For Alexandria's leaders, retrocession ensured that their slave property and the slave trade, an important component of the local economy, remained free from federal interference."

In modern times, the building has become an object of fascination. In the 1970s, it was known as the Norman Apartments until the Alexandria Department of Health condemned the building as unsafe. Then it sat vacant until 1980, when it was on the verge of becoming part of the condo-conversion craze sweeping the region in those days. According to a June 4, 1980 story in the *Alexandria Journal*, a limited partnership was able to persuade the Virginia Historic Landmark Commission and the United States Department of the Interior.

Thomas Stanton, trustee of the Franklin and Armfield Limited Partnership, told the newspaper that the condo-conversion plan for the historic slave pen included four one-bedroom units with dens and three one-bedroom units. The city's Department of Planning and Zoning actually approved this plan, although it fortunately never came to pass.

"Of all the historic documentation in this city, it is amazing that so little attention has been paid to this building," Stanton told the *Journal*.

These days, the building has a sense of victory over the peculiar institution. It's now the headquarters for the Urban League of Northern Virginia, a group that describes it mission as "empowering African Americans to enter the economic and social mainstream."

Boom and Bust

The Rise and Fall of Alexandria, D.C.

Being part of the District of Columbia did not help Alexandria's bottom line. In fact, the city's fortunes began to decline almost the moment it left Virginia.

Everybody knows that George Washington was the first president of the United States. Fewer know that he was the first president of the Patowmack Company. While as the former he changed history, as the latter he was somewhat of a bust. Washington's failure has been obscured over the years. But understanding it is key to following the life and times of Alexandria, D.C.

What the Patowmack Company was offering was essentially a deal that was too good to be true: invest in infrastructure and reap windfall profits by opening up the Potomac River to navigation. It was a grand design that was a sort of like Manifest Destiny in the eighteenth century, connecting east to west. By extending navigation of the Potomac River to the Mississippi River, George Washington hoped to open vast territory to commerce. He laid the foundation for the company in 1784 when he convened a group of commissioners to accomplish "the extension of navigation of the Potomac River from tidewater to the highest point practicable on the North Branch and to construct canals

The Patowmack Company's canal and locks at Great Falls, Virginia. *Library of Congress.*

and such locks…for opening, improving and extending the navigation of the river above tidewater."

Don't hold your breath. This story doesn't end well. Part of the reason for that is that the vision *was* so grand. The burgeoning nation had little experience with civil engineering projects, and almost nobody in America had a résumé that would have qualified them to lead such an endeavor. Europeans had developed the skills, but the young republic was sorely lacking in the know-how to make this happen. That left a choice of either hiring a European or sending an American across the pond for the purpose of learning the trade—neither of which happened.

Instead, Alexandria, D.C., became mired in a Ponzi scheme of sorts, one that was created by the Father of the Country and, therefore, more respectable. But it was a failure nonetheless, especially after Washington died.

Labor, both skilled and unskilled, was difficult to come by. That meant that the company relied on indentured servants and slaves, although that arrangement never quite worked out. As if that wasn't bad enough, political

friction was also a problem, threatening the project before it even began. Supporters of navigation on the James River proved to be a powerful lobbying force, one that posed a direct threat to the Patowmack Company. Then there was the merchant class of Baltimore, who opposed the idea as giving Alexandria and Georgetown an unfair advantage. Lingering in the background was a growing commercial rivalry between the sister cities of Alexandria and Georgetown, a bitter feud that became more pitched when both cities were incorporated into the District of Columbia.

"When efforts at Alexandria were initiated to improve development of the western trade, either through the promotion of a new road system or a canal, such as a venture with the Patowmack Company venture, political and economic warfare with Georgetown usually ensued," wrote Alexandria historian Donald Shomette.

From the start, the Patowmack Company was a bust. Mechanical engineer James Rumsey was charged with managing the ill-fated project, which was beset with endless difficulties. As time passed, the company continued to issue new stock even though there was waning interest in the scheme. In 1802, a segment of the canal and five locks were opened at Great Falls.

Yet even as the sluggish pace of construction continued in the early years of the century, a variety of problems mounted—commercial, financial and physical. One of the biggest problems was created by Congress, which approved construction of a causeway across the Potomac between Virginia and Mason's Island. Not only did the structure block passage from Alexandria and Georgetown, but it also made navigation treacherous. After the causeway was constructed, seafaring ships would avoid Alexandria for Georgetown. And fundraising became increasingly difficult. The company tried to sponsor lotteries and sell stocks in Amsterdam as the members of its board of directors schemed against one another.

"A majority of Directors at present reside in Alexandria, and nothing can be more clear than that the completion of the navigation will tend to reduce the commerce of that Spot," wrote Thomas Mason in a letter to the governor of Virginia. "Boats that bring the produce cannot navigate the river so low down."

The bridge proved to be a disaster for Alexandria, which had become dependent on access to the navigation of the Patowmack Company's improvements in the upper river above Georgetown. When traffic became impossible because of the obstruction, Alexandria requested that Congress grant permission to build a canal around the west end of the causeway. Congress consented on June 17, 1812. But the very next day, Congress issued a declaration of war against Great Britain, and the project was scuttled. Again and again, hopes failed to materialize. After the catastrophic War of 1812, federal money was tied up in rebuilding official Washington. That created another setback for Alexandria. "Few federal dollars flowed towards the Virginia portion of the district," wrote Shomette. "Modernization, however, managed to creep in by fits and starts."

Oil lamps lit the streets, and the Market House was outfitted with a cupola and a town clock. But the improvements did not come without a burden—debt. By 1819, the debt had swollen to almost $75,000. But the city's tax base failed to keep up with the debt load as the population stagnated. Census records show that the population of Alexandria, D.C., increased by only twenty-five people from 1820 to 1830. By 1840, the population had increased a little more, by about two hundred, but not enough for the city to handle obligations to the deadbeat District.

Alexandria was now in a state of rapid decline, and the debt situation continued to grow more and more burdensome. Interest payments on loans from Dutch merchants continued to be paid by the government of Alexandria even though the city no longer benefited. The cost of servicing the debt became crippling, and the prospect of a looming financial obligations continued to mount. If bond-rating agencies were around back then, the city would certainly not receive the "triple A" rating it enjoys today.

"Visited Alexandria," wrote an English traveler in 1835. "The business of this place was once very considerable, but owing to its proximity to Baltimore, and the tedious navigation of the Potomac, it has fallen off of late years very much."

The stars were never aligned for the Patowmack Company, which was unable to cope with the difficulties of river navigation or provide a dependable route to the West. The Erie Canal was already well underway,

A parody of the often-worthless fractional currencies or "shinsplasters" issued by banks, business and municipalities in lieu of coin. *Library of Congress.*

and other states had designs on their own canal projects. Yet the company directors stubbornly held on to their charter long after the dream had withered. Even after the company surrendered to the Chesapeake and Ohio Canal Company in 1828, the project was unable to reach the Ohio River.

The failure of the Patowmack Company would provide a lesson to promoters of the Chesapeake and Ohio, however. The first lesson seems elementary but was probably lost on a generation of men who lived beyond their means and died in debt. Generally speaking, it's not a good idea to move forward with a project until adequate financing is secured. Then there's the importance of aligning the interests of various jurisdictions behind a common purpose and a shared motivation. And don't forget to secure skilled labor and engineering talent.

By 1827, Alexandria was ready to abandon Washington's dream. Instead, city leaders took a leap of faith and sunk $250,000 to the development of the Chesapeake and Ohio Canal system. They were betting that the system would link the city to the coalfields of the west. By the time promoters of the C&O met the following year in Washington, D.C., for a convention, the ship had already run aground. But that didn't mean that Washington's dream had died—at least not yet. This was a time of renewed interest in public works, spurred in part by President

James Monroe's annual message to Congress in which he advocated support for the C&O Canal. Congress responded by throwing $39,000 at the project for a detailed study of the proposed canal route by the United States Board of Engineers.

Suddenly there was momentum. Virginia led the way, passing an act of incorporation for the C&O Canal Company in January 1824. That was followed by Maryland's confirmation in January 1825. Pennsylvania rounded out the trifecta in February 1826. President James Monroe signed the act chartering the Chesapeake and Ohio Canal Company on the last day of his administration—interestingly offering a preview for the last day in a different administration, the one led by President Dwight Eisenhower, who issued a presidential proclamation his last day in office designating the C&O Canal as a National Historical Monument.

The Alexandria canal was supposed to be forty feet wide at the water's surface and twenty-eight feet wide at the bottom. There was supposed to be a towpath along the side to accommodate horses or mules to pull the barges. The expenditure to make that happen was enormous, and the Alexandria Common Council passed a series of acts committing money to the project—the first of which was on July 23, 1830, purchasing five hundred shares at $100 each of the capital stock of the Alexandria Canal Company. The mayor and president of the council were authorized to borrow even more money on several subsequent occasions, throwing even more cash at the problem. Taxes were raised to handle the rest.

In the end, it was wasted money. The project was a failure, and Alexandria was left holding the bill. In order to secure the coal trade from Cumberland, when the great western canal was finished, the Town of Alexandria had now burdened itself with debt to build the Alexandria Canal and the aqueduct. After twelve years of labor that costly and difficult (for that day) engineering, work had been completed. Then, owing to lack of money, the work on the Chesapeake and Ohio Canal stopped while still short of the proposed terminus at Cumberland, and the money put into the Alexandria section was unproductive.

"The situation was a desperate one," noted Wilhelmus Bogart Bryan. "The same condition of financial and trade troubles in the case of Alexandria, six years after the bank episode, inspired largely the

movement which resulted in the restoration of the town and county of Alexandria to the State of Virginia."

The Patowmack Company disaster and the C&O catastrophe created a new sense of disenchantment. People in Alexandria were no longer looking favorably at the prospect of being part of the District of Columbia. Although the first effort for retrocession took place in 1804, the 1830s saw the movement take on a new life. The city's rapid decline had become a source of embarrassment, and the District of Columbia was perceived to be at fault.

Things got so bad in the 1830s that Alexandria was forced to petition the federal government for economic relief, although without success. As a result, the Alexandria canal took on increased importance. City leaders considered the canal a vital necessity to establish a link to the C&O. The idea was to create an aqueduct to allow barges carrying coal or produce to cross the river and unload in Alexandria. In 1833, construction finally began on the aqueduct under the direction of Major William Turnbull and Lieutenant Maskell Ewing.

When it was completed, the aqueduct was an engineering marvel featuring eight massive stone piers founded on solid rock thirty-five feet below the water. Running from Georgetown to Rosslyn, the system was designed to have a towpath with a highway and a canal flume of heavy timbers resting on top of the stone piers. The *Alexandria Gazette* heralded the public works project as a potential savior.

"As Alexandria is, and undoubtedly, from its excellent situation, must continue to be the Commercial depot of this populous District," the *Gazette* editorialized, "so, it seems to us, it also ought to be the MECHANICAL and MANUFACTURING mart for all this section of county. Much of our prosperity, in our opinion, depends upon this consummation, and we rejoice to think, that with the success of the Alexandria Canal, furnishing such a water power and such excellent sites as it will, this must ensue."

Despite the high hopes, Alexandria continued to lag behind other cities and towns. One visitor from England described Alexandrians as "exceedingly impolite."

"I allude to their 'want of faith,' in the prosperity of their city, and the ceaseless remarks as to its eventual decline," the Englishman wrote in

1835. "A stranger to hear them talk would suppose that all business had left them, and that the city, inhabitants and all, were going down to Davy Jones' locker at the rate of ten knots an hour."

Here the visiting Englishman is hinting at a sense of fatalism that was prevalent in Alexandria at the time. Davy Jones' locker is a nautical expression from the era that would have been understood at the time as a euphemism for death at sea, an indication of the moribund sense the city had of its future. Clearly Alexandria, D.C., was in an economic tailspin. Scenes of decay were everywhere—in the empty warehouses and along the weed-choked streets.

"The effects of this declension are beginning to be perceived in the great depreciation of property," the Englishman wrote. "I was assured that the very best houses in the place (and there are many excellent edifices) would not command a higher annual rent than 250 to 300 dollars."

Things would get worse before they got better. After the charter of the Second National Bank expired in 1836, inflation spiraled out of control. Many banks began to insist on accepting only gold or silver for

Anthony Imbert's 1833 cartoon satirizing President Andrew Jackson's order for withdrawal of federal funds from the Bank of the Second Bank of the United States. *Library of Congress.*

payments rather than paper money, creating a period of deflation. The instability gave rise to what's now known as the Panic of 1837, which led to a five-year depression with record unemployment and hundreds of bank closures. For Alexandria, it was a sucker punch.

"As her star was descending, others were ascending to take the place of the fallen brightness," wrote one observer in 1840. "Georgetown and Washington prospered at her expense…with the benefit of trade once confined to the better known Alexandria."

In 1843, Mayor John Roberts finally threw the ceremonial first patch of earth for the construction of the Alexandria Canal—seen by many as the last best hope for the portion of the District on the south side of the Potomac River. The project was completed at breakneck speed, opening just four months later. The December 4, 1843 issue of the *Gazette* described the ceremony: "In honor of the event a salute was fired, the national flag was hoisted at the Public Square, and the vessels in port were decorated with flags…May this important work succeed and prosper—may it more than realize our warmest hopes—and may it RESTORE and PERPETUATE the TRADE and PROSPERITY of ALEXANDRIA."

The canal was fifty feet wide at Four Mile Run and sixty feet wide into Alexandria. By 1845, four lift-locks had been constructed to lower canalboats almost forty feet into the Potomac River. From that point, the ships could unload their cargoes onto the wharves or sailing ships along the Alexandria waterfront. Construction of the canal cost about $500,000, much less than the $6 million Potomac Aqueduct Bridge.

"We have been enabled to construct at unusually low prices the Locks & other works of the Alexandria Canal here, owing to the proximity & easy transportation of materials of wood or stone, in abundance & of unsurpassed quality."

The completion of the canal provided a much-needed stimulus to Alexandria. Despite the depression prompted by the Panic of 1837, the canal basin became a bustling scene. Suddenly the city was flush with all manner of goods coming down the canal to vessels waiting along the waterfront, including flour, corn, lime, whiskey, wheat, rye, oats, bran, cloverseed, lumber, potatoes, coal, wood, nails, barrel hoops and ship stuff.

Wagons began arriving from across the region. Buyers met sellers. City wharves were soon crowded as the wheels of commerce began to turn once again. Merchants began to have some measure of confidence. New stores opened, and new homes were constructed. *Gazette* editor Edgar Snowden, who had taken over control of the paper from his father, Samuel Snowden, editorialized that Alexandria "only needs proper exertions to make it one of the most desirable markets for Valley produced that can be found."

Alexandria's canal was so successful that other towns along the Occoquan Bay began dreaming of building one of their own. Maskell Ewing, one of the major forces behind the canal, began talking about building a dry dock to take advantage of sulfur-free Maryland coal, which was considered the ideal for steam engines. Alexandria was finally making a comeback—thanks to the canal.

"The canal had preserved Alexandria's original reason for being," Alexandria maritime historian Donald Shomette concluded, "to function as a transfer point between the hinterlands and the sea."

WICKED ALEXANDRIA, D.C.

Life on the Wild Side

Two decades into its ordeal as a failed federal experiment, Alexandria, D.C., was the only jurisdiction in America where theft was a capital crime. The reason for this was the haphazard way the city was incorporated into the District of Columbia, essentially freezing the existing Virginia laws of the era—a drastically different time in American jurisprudence. Yet while other localities were standing down from the harshest of sentences, Alexandria, D.C., was stuck in the past. Not only was theft a capital crime, but stealing as little as four dollars' worth of merchandise could also send a man to the hangman's gallows.

Life was short, and justice was swift. "Alexandria is one of the most wicked places I ever beheld in my life," wrote one English visitor in the early nineteenth century. "Cock fighting, horse racing, with every species of gambling and cheating, being apparently the principal business going forward."

Crime and deviant behavior were rampant in Alexandria, a port city with its fair share of fisticuffs, brawls and knifings. Being at the center of an international crossroads meant that the city was populated by a diverse mix of sailors from distant ports of call. Spanish, French and Portuguese could be heard along the city's cobblestone streets and alleys as seamen

The Alexandria federal courthouse once stood on south Columbus Street. *Alexandria Local History Special Collections.*

searched for good rum and easy women. That created a pastiche in the city's thriving taverns and ordinaries.

Those who were found guilty were generally fined or required to post bonds, although sometimes the punishment was much more severe. For example, when William Dalton received a stolen sheep from a slave in the late 1700s, he was sentenced to thirty-nine lashes on his bare back at the public whipping post. By 1753, the courthouse was moved from Springfield near modern-day Tysons Corner to Alexandria. In those days, the jail was situated next to the courthouse in Market Square along with the stocks and a pillory.

When Alexandria incorporated in 1779, the newly formed police department fell under the jurisdiction of the Alexandria City Council. By 1780, the force had grown to one policeman and two night watchmen who received an annual salary of $150. By the time Alexandria became a part of the District of Columbia, the police department boasted a

superintendent of police, six watchmen and one officer—a force that cost the city $1,650 per year. By January 1805, the city council passed an ordinance that allow the mayor to appoint additional constables at his own discretion as long as each new constable posted a bond of $300 to ensure faithful performance in office.

"Eighteenth and nineteenth century Alexandria entailed more than birthnight balls, barbeques, horse races and elegant receptions," wrote city historian Michael Miller. "Beneath this chimerical cloud there also lurked segments of society who engaged in robbery, arson and even murder to advance their malevolent schemes."

Presiding over it all was a man named William Cranch, chief judge for the federal court Alexandria. For the entire duration of Cranch's time on the bench, Alexandria was part of the District of Columbia. The six volumes of his circuit court reports read like a hidden history of the early

Judge William Cranch.
Library of Congress.

years in the District. His courtroom saw it all, everything from murder and mayhem to dishonesty and fraud. Through it all, Cranch maintained an old-fashioned sense of justice—often sentencing men to the whipping post or being branded by the key to the jail.

"Cranch was a plain, honest judge, incorruptible by circumstance or by men," wrote William Carne in a 1901 profile of Judge Cranch. "He never wore a coif or wig; no gown of silk was needed to make him an imposing judicial presence."

A native of Massachusetts, Cranch was born at Weymouth on July 17, 1769, a time when New England was buzzing about the presence of British troops in Boston. The Boston Massacre happened when Cranch was but an infant, and the first impressions of his world may have been largely shaped by what happened at Lexington and Concord. His father was a judge of the Massachusetts Court of Common Pleas. But the young Cranch struck out on his own, eventually being appointed by President Thomas Jefferson to the newly created federal court in Alexandria.

For an idea of Cranch's sense of justice, consider the case of a cooper named Davis and a black man named Hull. Davis had cut the throat of a fellow workman and been convicted of murder. Hull had feloniously entered the storehouse of Clark & Cook and stolen four dollars. Both men appeared before District Court Judge William Cranch at the same time. Without hesitation, the judge sentenced the murderer to death. Then, turning to the thief, who stood trembling at the bar, he delivered his sentence. "Richard Hull, you have been convicted of feloniously breaking and entering the storehouse of Leonard Cook and James Clarke, and taking therefrom goods of a greater value than four dollars," Judge Cranch explained. "The punishment which the law in force in this county has affixed to this crime is death."

Hull was a man with a rap sheet. In fact he had been tried in Cranch's court for a similar crime in the past, although a jury acquitted him. But the judge apparently felt he got off easy because as he was sentencing him in the Clark and Cook matter, he declared that "few who heard the trial could doubt your guilt." Cranch acknowledged that a capital sentence was more severe than the other county in the District—that would be Washington, D.C.—but he added that the circumstances in Clark and Cook excluded the hope of a pardon.

"And now it becomes my duty to pronounce the sentence of the law, which is that you be taken hence to the place whence you came; and thence to the place of public execution, and that you be there hanged by the neck until you be dead," the judge thundered. "And may God Almighty have mercy upon your soul."

God may have had mercy on Hull, although it was President James Monroe who commuted his sentence. Yet even if Hull was fortunate to have avoided the gallows, hundreds of other defendants were not so lucky. This was crime and punishment in Alexandria, D.C.

Much of the justice meted in Judge Cranch's courtroom would be considered torture by modern standards. As late as 1835, he sentenced a man named H. Sly, convicted of "flagrant assault," to being branded in the left hand and to receive twenty-five strokes. In Alexandria, branding was performed with the handle of a "ponderous jail key." "In the later years, it was never heated very hot," explained Carne.

Cranch's courtroom included everything from the sacred to the profane, displaying the full range of human foibles and imperfections. One of the most famous took place in 1829 and involved a woman by the name of Anne Royall, considered by some to be the first female journalist. Others considered her a common scold. Some were even willing to press charges that Royall was "a common slanderer and disturber of the peace and happiness of the good people of the neighborhood." Cranch tried to keep an orderly courtroom, but the wily Royall conducted her own defense in what has widely considered the comic trial of the century.

The history of Alexandria is a tale full of vice and moral turpitude. One of the earliest stories involves one of the most elite men to walk the scraggly sidewalks of Old Town in Alexandria: George Washington Parke Custis. If the name rings a bell, it's probably because he built a plantation estate known as Arlington House that later became the heart of Arlington National Cemetery. He was also a youthful felon.

Known as "Washy" to the couple who raised him at Mount Vernon, George and Martha Washington, the young George attended Princeton College in New Jersey before receiving a commission to the United States Army. He eventually became an aide-de-camp to General Charles

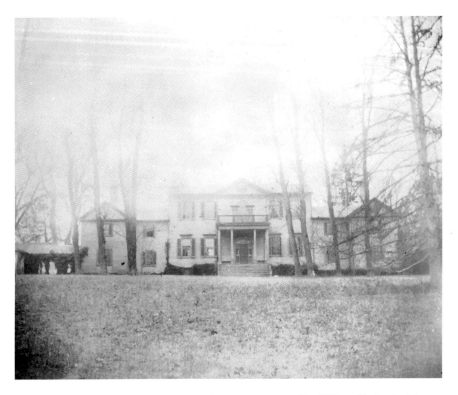

Ravensworth is the Fairfax County plantation that was owned by William Fitzhugh. *Library of Congress.*

Pinckney. In 1804, he married a girl, Mary, raised on the Fairfax County plantation known as Ravensworth, daughter of Virginia gentleman and landed gentry William Fitzhugh.

George constructed one of the most infamous houses in Virginia for Mary, although neither of them would know it at the time. In the beginning, the plantation estate was like an idyllic painting. The Custis house became a museum for all things Washington, and much of the general's personal belongings were on display at the house with a sweeping view of the other District of Columbia—the one where the issue of slavery was tearing the Union apart.

But Custis had a bachelor's existence before assuming the life of leisure. At an Examining Court proceeding in the summer of 1798, he answered a charge from authorities in Alexandria that he entered the house of innkeeper John Gadsby and stole two silver spoons valued at

two dollars each. But Washy failed to appear in court. "It is ordered that his recognizance be prosecuted," the court record notes.

Imagine the surprise at Mount Vernon when the general and his lady heard about the felony charges. The genteel nature of Virginia society would have required a sense of embarrassment upon learning of the case. It's possible that the crime took on an added sense of shame because the allegedly pilfered items were silver spoons from Gadsby's Tavern.

In the annals of Alexandria history, the crime still leaves many unanswered questions. Why did John Gadsby bring charges against the grandson of Martha Washington? Who paid bail for George Washington Parke Custis? Why did he fail to appear in court? Did George Washington intervene? Inquiring minds want to know. Unfortunately, there are no answers in this case.

Even when the answers are not always evident, the motivation for certain crimes seem unmistakable. Such was the case one summer day in 1805,

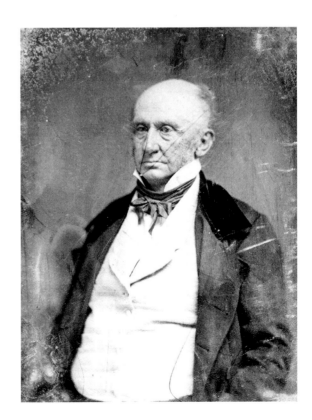

George Washington Parke Custis. *Library of Congress.*

when a clerk at the Bank of Columbia by the name of John Peters was on his way from Georgetown, D.C., to Alexandria, D.C., carrying about $17,000 in notes of the Bank of Alexandria. He was supposed to exchange them for cash or Columbia Bank notes, although a darker fate intervened.

According to a harrowing account published in the *Alexandria Expositor*, Peters was intercepted about 9:00 a.m. on July 31, 1805, at a small branch near a hedge of briars by a young man wearing a black coat and nankeen pantaloons, who approached from one side of the road as if he were crossing it. Yet when he was near the horse, he seized its bridle and shot Peters with a pistol. After stealing the money, the thief ran off with the money and left the wounded clerk for dead.

The genteel appearance indicated that he was a man of means, creating a twist to this dastardly crime. It wasn't simply a run-of-the-mill robbery. Today we would call it a white-collar crime, although at the time they might have referred to it as a nankeen-pantaloons crime. The *Gazette* descried the mugging as "the most daring robbery every perpetrated in America," ostensibly because of the amount of money that was taken. As word spread of the crime, Alexandria residents formed a posse to track down the criminal and bring him to justice. They spotted two genteel-looking men crossing the Potomac River at the Georgetown ferry, although the vigilante crew was apparently unable to catch the duo.

"It is not improbable but the above were robbers," the *Expositor* conjectured. "Their objective now is to gain the back country and hide themselves in its vastness until the search shall be over."

One of the most infamous crimes that happened during Alexandria's federal period was the curious case of the steamboat *Sydney*. This is where President Andrew Jackson was attacked while visiting the port city in 1833. At the center of this wicked tale is Robert Randolph, a controversial navy lieutenant who served under Commodore Stephen Decatur in 1812 when he captured the *Macedonia*. The famous commodore was summoned to the Mediterranean a few years later in 1816 to handle the Barbary Coast pirates. For some reason, Randolph was dismissed from the navy after seventeen years and charged with "improper conduct," although version of events has him "triumphantly acquitted, notwithstanding the whole weight of the government had been thrown against him."

Steamboats were an increasingly popular form of transportation for the era. The *Norwich*, built in 1836, is likely similar to the way the *Sydney* must have looked. *Library of Congress.*

Jackson and Randolph apparently did not get along. The commander-in-chief was described by Randolph's supporters as eager to condemn the lieutenant, a perception that seems borne out considering the insulting language used in the letter of his dismissal. Even though Randolph had been acquitted of wrongdoing, Jackson was giving him the axe. The president no longer considered him to be fit to serve with the "sons of chivalry," as he liked to call the navy officers. "It was this language which excited Mr. Randolph to the pitch, almost of madness, and which led to the assault upon the president," explained an 1850s account in *Harper's*.

Old Hickory was apparently on his way to Fredericksburg when it happened. The *Sydney* was docked at the wharf in Alexandria with "a large number of distinguished ladies" when the president retired to the cabin and sat behind a table next to the berths to quietly smoke and read. This is when Robert Randolph arrived on the scene, obviously still distraught at the personal slight from Jackson.

"I do not know you," Jackson told Randolph as he drew closer.

"Here is your own letter written to me," Randolph replied, waving the document.

The president ordered Randolph to leave the boat, adding that he was finished with their conversation. That didn't sit well with the hotheaded former naval officer, who lunged at Jackson in anger. Some say that Randolph struck Jackson in the face. Others say that he merely seized his nose. Whatever the case, Randolph didn't have occasion to strike a second time. Almost immediately, the captain of the ship seized the former lieutenant and punched him in the ribs. Then a clerk in one of the departments got into the act. Before long, it was a free-for-all as Randolph was pelted with umbrellas and sticks.

"Almost a hundred arms fell upon the assailant, and he was with difficulty rescued and carried on shore," according to an account in

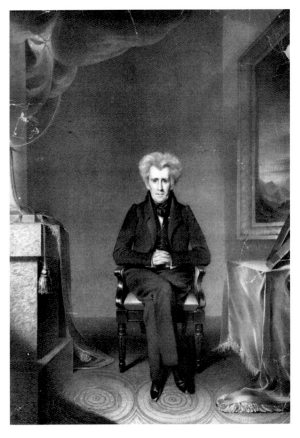

President Andrew Jackson. *Library of Congress.*

the *Alexandria Gazette*. "The president was naturally highly excited and exasperated—he departed amidst the cheers and good wishes of the great crowd which had assembled."

According to one account, court was in session when the assault took place. So Randolph was taken to the grand jury, and a bench warrant was secured on the spot. Another version of events had the impromptu vigilante squad taking him ashore, where he escaped. Back on the boat, according to a contemporaneous version of events, President Jackson was attended to with vapors. Whatever transpired that day, it must have been embarrassing for Jackson, who prided himself on his sense of toughness. As historian Daniel Walker Howe pointed out in his 2007 book *What Hath God Wrought*, President Jackson had a firm belief in the legitimacy of private violence. "No villain has every escaped me before," the president declared, according to the *Harper's* version of events. "And he would not but for my confined situation."

Randolph was spotted on the wharf later that day. "He manifested the most imperturbable calmness," according to an 1854 account in the *Alexandria Gazette*. "The first word he spoke was to order a servant to go on board for his hat, which had fallen off in the scuffle."

Alexandria, D.C., became embroiled in controversy. Outraged citizens descended on Market Square to demand action. Mayor Bernard Hooe convened a town meeting and yielded the floor to Thomson Mason, who delivered a barnburning speech castigating Randolph. Then Mayor Hooe presented a resolution, which had overwhelming support:

Resolved, That the Citizens of this Town have learned, with mingled sentiments of regret and indignation, that a flagrant violation of the public peace, and of the sanctity of the laws, was, yesterday, committed on board the public Mail Boat, whilst lying at our wharves, by Robert B. Randolph, on the person of the President of the United States.

Resolved, That, in the outrage which has been committed, the principles of our Free Institutions have been violated; and that, in the manner and circumstances of its perpetration, there is nothing found to extenuate it, or all the feelings on injured and indignant people.

Resolved, That in the history of our country, it is the first time, within the knowledge of this meeting, that an attempt has been made to gratify a personal vengeance, for the results of a high official act—and this blow at the fundamental principles of our institutions has been struck by an arm, to which had once been confided the high trust of upholding the flag, and defending the character and honor of his country.

Resolved, That the Chairman be requested to enclose a copy of the proceedings of this meeting to the President of the United States, and also cause them to be published in the newspapers.

Once again, the story illustrates a problem with the overlapping series of jurisdictions. Randolph escaped to Fairfax County, just a few miles west. But because Alexandria was in the District of Columbia at the time, the arrest warrant could not be served. Jackson chose not to pursue the matter, and the issue was subsequently dropped. After the assault, Randolph lived in poverty and obscurity, although his friends say that he maintained his sense of dignity and integrity to the last day. He once took public office to support his family, but another public outrage forced him from the position. Randolph died in 1869, many years after Alexandria left the District.

"The writer of this, in former days, knew him intimately," wrote one *Alexandria Gazette* correspondent on April 27, 1869, "and can beat testimony to the many estimable traits of character he possessed."

CITY IN OPPOSITION

City Zigs When Commonwealth Zags

S tep right up and announce your vote. Who is it going to be? The candidate who plied you with liquor in Market Square? Or will it be the one who presented you with a sample ballot while you were waiting to see the election judge?

The choice was yours. But that doesn't mean it was private. This was an era of public political participation. Everybody knew your business. When your turn with the judge arrived, you placed your hand on the Bible and swore that you had not already voted. You could feel the candidates watching you as the judge asked how you will be voting. You voted with your voice. *Viva voce*, as it was known at the time.

It was a raucous scene, showing how noisy and complex democracy can be. People from "the county part of Alexandria," a place now known as Arlington, met with city folk. Oftentimes, they had political disagreements about candidates and issues. People from the country tended to favor Andrew Jackson and his Democratic Party. Along the waterfront, support was strong for lowering tariffs and allowing for as much interstate commerce as possible. Some even dreamed of interstate improvements as part of a vision for transportation.

Candidates for political office were expected to provide alcohol on election days. If they didn't bring any liquor—or not enough booze to win—they risked being beaten. Such was the case when twenty-four-year-old George Washington lost his first election for the Virginia House of Burgesses, a mistake he did not repeat in future elections. In later years, the practice would be known as "swilling the planters with bumbo."

Alexandria has always been a political town, although it has not always been in lockstep with the rest of Virginia. In fact, the city has long held the status of outcast, supporting a different slate of candidates than the ones who won the commonwealth. That's a tradition that dates back to the earliest days of the city, when city voters supported John Adams over Virginia patriarch Thomas Jefferson.

As the Revolution of 1800 began building momentum across the eastern seaboard, the port city of Alexandria, D.C., became a hotbed of political intrigue. When the campaign began organizing local political action

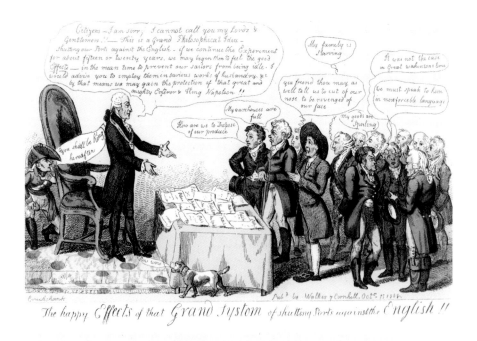

President Thomas Jefferson is depicted addressing a group of disgruntled businessmen as he defends his embargo. *Library of Congress.*

committees to get out the vote, Fairfax County organized a group of heavy hitters: Roger West, Francis Peyton, Thompson Mason and Walter Jones. And from Alexandria, there was the future mayor, Elisha Cullen Dick.

By choosing Jefferson as its standard bearer, Republicans were practically guaranteeing that all of Virginia's twenty-one electoral votes would swing their way. In Richmond, a Republican-controlled General Assembly passed a bill calling for the selection of presidential electors on a general ticket rather than by districts. Because they had the majority, the Republicans could eliminate any chance that a Federalist elector would be appointed.

The Federalists, however, were up for a fight. Incumbent President John Adams found time to conduct some official campaigning during an 1800 visit to the District of Columbia, stopping along the way to visit Martha Washington at Mount Vernon. "The great man [Adams] has been south as far as Alexandria," Massachusetts Federalist Fisher Ames wrote, "making his addressers acquainted with his revolutionary merits."

By October, the politics of America's most interesting election reached a fever pitch. One Republican meeting at the courthouse culminated in the unanimous adoption of a resolution. The text of the document was published the next day in the *Alexandria Gazette*, the equivalent of the modern-day grip card laying out the case for a candidate.

"The Election of Thomas Jefferson, as President of the United States, will greatly conduce to the preservation of a free, republican and efficient government," the tract explained. "He is eminently qualified to discharge the important functions attached to that office."

The resolution also appointed committees to oversee the political operation that would take place on the day of the election. A sixteen-member get-out-the-vote committee was ordered to "give every necessity aid in assisting voters to attend the ensuing election." A five-man panel was created to write and publish "addresses…calculated…to justify to our fellow citizens, and to impress an honest conviction of the truth of the opinions expressed by this meeting." Newspaper announcements show that the group met in Archibald McClean's schoolroom.

When election day finally arrived, the anticipation was overwhelming. The next day, *Gazette* editor Samuel Snowden announced that "it is not

Samuel Snowden. *Alexandria Association.*

in my power to gratify my readers with a statement of the votes." Even though Snowden did not have the numbers at his disposal, the editor gave his readers an indication of the city's political situation.

According to "several respectable gentlemen," Snowden reported, "Mr. Adams' friends must have had a considerable majority."

Thomas Jefferson carried Virginia by about twenty thousand votes. Even though he was unable to win a majority of Alexandria voters, the president-elect chose Gadsby's Tavern as the location for his inaugural banquet. All twenty-three windows of the hotel were illuminated that night, shining the way into a new future for the United States and for Alexandria. This was to be the last time Alexandria voters were allowed to vote for president. From now on, there would be no participation in choosing the country's chief executive.

The president arrived at 2:00 p.m. on a Saturday afternoon in February, escorted by a cavalry detachment. The banquet itself featured speeches from the incoming president, vice president, secretary of war and attorney general. That was followed by a round of lively toasts.

"Prosperity to the Town of Alexandria," proclaimed the president.

"The memory of our departed chief, George Washington," Burr added.

"Mrs. Washington," Secretary of War Henry Dearborn chimed in.

"The District of Columbia," interjected Attorney General Levi Lincoln, "may the official fire in the centre warm the extremities of the union."

The official fire didn't do much to warm the body politic in Alexandria. For the next eleven presidential elections, Alexandria voters would not be able to cast a ballot for president. But that hardly meant that the city lacked presidential politics. Quite the contrary. Being part of the District of Columbia—and a former part of the commonwealth—gave Alexandria residents and voters a front-row seat to the greatest show on earth: American politics. This was especially true because the city's fate was so closely tied to commercial shipping.

"Although Alexandria citizens could not vote during this interval," wrote Alexandria historian Michael Miller, "they exhibited an intense interest and zeal for national politics."

Political clubs were commonplace in the city, and their members worked feverishly to influence the electorate. This was the era of barbecues, picnics, illuminations and torch-lit marches. And even though Alexandria freeholders could not vote, those who owned property in nearby Fairfax County were able to cast a ballot for president. As a result, the politics of what happened in Alexandria carried a certain indirect influence.

Commercial shipping was the coin of the political realm in Alexandria, and the Jefferson administration did not acquit itself well by this standard. In 1806, the president declared an embargo that nearly destroyed the city's economy. The effort was aimed at forcing England and France to respect America's neutral rights, but the effort was an unmitigated disaster—at least in Alexandria, D.C.

"Alexandria was eight years ago a very flourishing place," wrote English visitor in 1807. "The town has but two or three ships in the trade with Great Britain, and there is little prospect of its ever attaining to its former prosperity."

During the Jeffersonian era, the political landscape in Alexandria was divided between the Democrats and the Federalists, also known as the Whigs and Tories or, more to the point, the English party and the French party. Democrats, or Whigs, were French partisans while Federalists, or

Tories, supported the British empire. That put Alexandria's financial interest squarely in the realm of the Federalists, especially considering Jefferson's embargo.

"It was formerly a flourishing town, and carried on an extensive foreign trade," wrote an English visitor known as the Rambler in 1824. "But a great number of vessels belonging to it were captured by the French in the West Indies, during the presidency of Mr. Adams, and the yellow fever raged there very violently a few years previous to my arrival."

War and pestilence conspired to diminish the city's commercial importance. The city had none of the pomp or grandeur of a city with wealth and power, a phenomenon that robbed the city of its pride and hauteur. It also flattened the social sphere, with little distinction between the classes of whites—with the exception of the very worst. The Rambler noted that a young man of genteel dress and manner could obtain admission into any social group by merely conducting himself respectably.

"Their leisure hour were spent in scenes of debauchery and vice," observed the Englishman. "Quarrels were frequent, and one quarter of the town, where women of the worst description congregated, and where houses were always open for visitants, and the song and dance were continually to be heard, was nightly the scene of broils and riots."

The political fallout from Jefferson's embargo lasted for many years, long after Jefferson departed the Executive Mansion. Between 1802 and 1808, exports declined from $108 million to $22 million. The measure was so unpopular that Jefferson repealed it three days before leaving office. But by then it was too late. The damage had been done, and Alexandria suffered greatly during the trade restriction.

Even more disastrous for the city's commercial fortunes was the War of 1812. The port was blockaded by British, whose warships sailed up the Potomac River in 1814. They captured the city and sacked its warehouses, causing almost $100,000 in damage to foodstuffs and grain. Aside from the financial hit sustained at the hands of the British empire, Alexandrians were humiliated. Alexandria surrendered the city without mounting a defense, a decision that saved much of Old Town for posterity. Yet it was a decision that had unintended consequences.

"Besides the financial and monetary losses, Alexandrians were humiliated nationally because they had surrendered the town without a shot," wrote Miller, who spent nearly three decades as the city's one and only official historian. "The invasion was a major contributory factor which led to the demise of the seaport in Alexandria."

During Jefferson's reelection campaign in 1808, Fairfax County supporters gathered at a tavern owned by Resin Wilcoxe in October to plot a strategy for election. The inevitable resolution adopted at the end of the meeting described the freeholders as having "undiminished" confidence "in the wisdom, patriotism and integrity" of the president. In expressing support for President James Madison's disastrous invasion of Canada, the Fairfax freeholders expressed outrage that the British orchestrated "direct attacks on our Independence, as to call on our government for prompt and efficacious measures to counteract them."

To hear Jefferson's supporters, one would think that "every principle of patriotism" was at stake. According to the resolution they unanimously adopted at Wilcoxe's tavern, the rule of law should not be sacrificed "at the altar of the public good." That meant "zealously" supporting Madison and his march toward war. One month before the election of 1808, Samuel Snowden's *Alexandria Gazette* carried a report of a Democratic party meeting at the Fairfax County Courthouse. Because the editor's politics clashed so dramatically with the Democrats, Snowden felt it necessary to offer and editorial comment on the proceedings.

"We beg leave most heartily to enter our protest against the sentiments therein contained," Snowden wrote on October 7, 1808. "They have the privilege when conveyed for such propose to stigmatize persons as respectable as themselves."

The *Virginia Gazette* was also a partisan newspaper, although a little more emphatically so. In a late October tract, the newspaper lambasted Madison as a former Federalist and a fraud. In an unsigned editorial published in late October, the closing days of the election of 1808, the Williamsburg newspapermen explained they would never forgive Madison for his association with the opposition party: "He has deserted the principles of WASHINGTON, and become a proselyte to democracy—nay, we consider him as having submitted, without a

Artist George Cruikshank's "A Sketch for the Regent's Speech on Mad-ass-son's Insanity" depicts Gabriel blowing a message at President James Madison, who is standing between Napoleon and the devil. *Library of Congress.*

struggle, to the tyrant of the world!! 'FRANCE WANTS MONEY, and we must give it'—for such a man we ought not to vote."

Representative Hall, a part of the modern Capitol that is now home to the old Senate chamber, was filled beyond capacity for the inauguration. One contemporaneous account described ten thousand people standing outside the hall. An hour before noon, the Senate was convened by Senator John Milledge of Georgia, founder of Athens and former governor. Foreign ministers were seated to the left, and outgoing president Thomas Jefferson was seated at the right. Supreme Court justices claimed the front row. Chief Justice John Marshall administered the oath of office. "Two rounds of minute guns were fired," reported the *Alexandria Gazette*, and "refreshments were liberally distributed."

War fever erupted at the beginning of the Madison administration. Once again Alexandria, D.C., opposed the party in power. The election of 1812 was essentially a national referendum on war, with Madison and war hawks in Congress pushing the country toward a formal declaration of hostilities. *Alexandria Gazette* editor Samuel Snowden supported former

New York Mayor DeWitt Clinton, the Federalist candidate who tried to build a coalition of people who were for and against the war. From his perch at Lafayette Square, historian Henry Adams declared that "no canvas for the presidency was ever less creditable than that of DeWitt Clinton in 1812," although he seemed to have support across the river in the Virginia portion of the District of Columbia.

"The approaching election may be considered as a suit, in which DeWitt Clinton is Plaintiff, and James Madison, Defendant," one *Gazette* correspondent explained shortly before the vote in November. "And, still further to gratify your curiosity, you may know that, when the trial comes on, my testimony will be in favor of the Plaintiff, DeWitt Clinton; and, of course, for ousting the present incumbent, James Madison."

Federalists in Alexandria did not get their wish. Madison sailed to reelection, and war was declared. Alexandria was occupied by British forces, and the Capitol was burned until a hurricane swept into town and put out the fire. The Executive Mansion was painted white to hide the damage, and Alexandria, D.C., remained hostile to the party in power. After a very brief "era of good feelings," partisanship erupted again in

Cartoonist David Claypoole Johnston's "A Foot-Race" shows the politics of the 1824 presidential election. *Library of Congress.*

an ongoing feud between John Quincy Adams and Andrew Jackson. Adams won the first round, vanquishing Jackson in the election of 1824. The Massachusetts scion made an appearance at an inaugural ball in Alexandria, D.C., at Clagett's Hotel, now known as Gadsby's Tavern. Alexandria Mayor John Roberts was there along with council president J.C. Vowell and other elected officials.

"Every toast was followed by a suitable number of guns and by appropriate music from a full and splendid band," the *Gazette* reported. "The President and the distinguished guests who accompanied him, retired about 8 o'clock, and returned to Washington in carriages."

The early federal period is sometimes called the "Age of Jackson," although that gives Old Hickory too much credit. He was never all that popular in Alexandria, D.C., where the opposition party eventually began

A caricature of Andrew Jackson as a despotic monarch, probably issued during the autumn of 1833 in response to the president's September order to remove federal deposits from the Bank of the United States. *Library of Congress.*

calling itself the Whig Party to imply that Andrew Jackson was acting like a dictatorial monarch. Historian Daniel Walker Howe illustrated the use of the adjective "Jacksonian" to describe the period as "unfortunate."

"Jackson was personally well experienced in the techniques of bribery, intimidation and fraud through which treaties were imposed on reluctant peoples, having been active in securing a series of land cessions by the Civilized Tribes since 1816," Howe explained. "Claiming to be the champion of democracy, Jackson provoked opposition from the strongest nationwide democratic protest movement the county had yet witnessed."

So much for the Age of Jackson. In Alexandria, D.C., it was the Age of Clay.

The Age of Clay

Whiggery in Alexandria, D.C.

A few weeks before the election of 1828, the *Alexandria Gazette* reported what it called "a sign in Virginia." At the general muster in Fairfax County, "the Jackson men were very active in endeavoring to get the people to take the Jackson tickets." Although the newspaper explained that the Democrats were able to dispose of only fifty among several hundred, the development struck a chord with newspaper editors aligned with President John Quincy Adams. "We expect the county of Fairfax will do her duty," the *Gazette* proclaimed.

Fairfax did, indeed, vote for Adams. But Jackson swept the commonwealth and claimed all twenty-four electoral votes that year. When it became clear that Jackson was victorious over Adams, the town of Adams, New Hampshire, changed its name to Jackson. But not everybody was celebrating. The *Gazette* expressed "sorrow" at the election returns. There was no love lost for Old Hickory. "In spite of sectional prejudices, and personal antipathies, thousands of intelligent Virginians have declared themselves in favor of the present administration," the newspaper exclaimed, "and opposed to the success of a mere Military Chieftain."

The *Gazette* carried an advertisement for "a cheap and convenient conveyance to Washington" for the inauguration. The following day, the

"The Hunter of Kentucky" depicts Henry Clay as a predator, with various Democrats as his prey. *Library of Congress.*

newspaper reported, the event "passed in the greatest harmony." But the city was not singing from the same hymnal. Jackson and his Democratic machine remained unpopular in the port city, despite their dominance on the national political scene. When Martin Van Buren, Jackson's chosen successor to the Democratic machine, was on the ballot in 1836, Fairfax County once again sided with the opposition. In Jackson's second administration, leaders of the opposition began calling themselves Whigs—a reference to antimonarchical British politics that cast Jackson as King Andrew I.

"In reviewing the political life of Martin Van Buren, one of the Candidates for the Presidency to the U.S. we can find nothing in his character to challenge our admiration or respect, no distinguishing act of patriotism to command our gratitude," exclaimed a Whig resolution adopted at a Fairfax County party meeting in October 1836. "And no merit of his own, except the particular favor of Gen. Jackson (if that may be called a merit) and resting his hopes of seating himself in the presidential chair."

The Whigs charged that electing Van Buren vice president would be "destructive of the rights of the people" and "a fatal stab at the spirit of

the Constitution itself." Party leaders pledged "all fair and honorable" means to defeat them in the election. But the nascent party was not organized enough to coalesce around a single candidate or even organize a convention. Instead, party leaders adopted a strategy whereby each of the various Whig candidates was to stand for president in the region where he was most popular.

William Henry Harrison became the Whig candidate of the West. Daniel Webster was the standard-bearer in the Northeast. Hugh Lawson White was the Whig choice of the Deep South. The plan was to deny Van Buren a majority and throw the election into the House of Representatives. Needless to say, the plan failed miserably.

Even the Fairfax County Whig Party resolution, published in the October 20, 1836 issue of the *Alexandria Gazette*, failed to identify a candidate to vote for—only mentioning the candidate to oppose. The newspaper referred to the "Anti-Van Buren" vote prevailing in Fairfax although said nothing of favored candidate. But even if the political character of Fairfax was Whig, the smart money was on the Democratic machine.

"We have observed with regret that for some years past, the reprehensible and ruinous practice of betting upon elections has been steadily but rapidly increasing," the *Gazette* noted after the election. "The rich and the poor, as shewn by the election just past are equally affected with the mania for political betting."

The Whigs finally got their act together for the election of 1840, adapting the methods of religious tent revivals and fitting them into a political context. In Alexandria, the new momentum was evident to the editor of the *Alexandria Gazette*, who denounced President Van Buren's White House as a "corrupt administration."

"Who, that knows the history of parties in Virginia for the last four years, can, for a moment, believe that Virginia will vote for Martin Van Buren?" asked the *Alexandria Gazette* in an October 22, 1840 editorial. "Van Burenism, in Virginia, has been going down, down, down, and the November election will show that it has sunk lower than friend or foe has ever imagined."

As the fateful election of 1840 drew nearer, the *Gazette* began sounding alarms about "several devices, which the office Holders intend using [to]

Artist Edward Williams Clay's apocalyptic allegory of public opinion as a giant lever tilting decisively in favor of the Whigs during the election of 1840. *Library of Congress.*

deceive and defraud the People." One plan was to start a rumor that Harrison was dead, a morbidly prophetic conspiracy theory considering that the hero of Tippecanoe was not long for this world. Another Democratic dirty trick that was apparently in the works, according to the *Gazette,* was to place an additional name on the Whig election ticket and circulate the fraudulent document as the ticket of opposition. Yet another conspiracy theory mentioned by the newspaper involved a faked letter from a Whig candidate or committee asserting "odious or unpopular doctrines." Members of the Alexandria club, who met at Mechanics' Hall on North Alfred Street, feared "secret plots" and "underhanded maneuvering."

"The schemes of the Custom House clique and their satellites in this town in relation to the election in Fairfax are well known and will be exposed to the people of that county," declared a resolution of the Democratic Tippecanoe Club of Alexandria.

This was an age when newspapermen carried a certain amount of significance, one that was on the rise. According to historian Daniel Walker Howe, newshounds of the era "played key roles in politics and

patronage." That included Edgar Snowden, the second-generation editor of the venerable *Alexandria Gazette*, who proclaimed that he would never use his press as "a vehicle for detraction on abuse." Edgar Snowden penned an editorial published on Halloween 1840 encouraging voters to vote Whig for the good of the country. "We desire not to be considered PARTIZANS," Snowden explained, "and our constant effort has been to make our readers patriots, not politicians."

The newspaper described "a large and enthusiastic meeting of the Whigs of Alexandria" held at Mechanics' Hall, which became the party headquarters for the duration of the campaign. Their candidate was William Henry Harrison, the Indian-fighting war hero now retired from the United States Senate. He was living the plantation lifestyle until he had became involved with Whig politics, standing as the candidate of the northern wing of the Whig party in its disastrous bid to throw the 1836 election into the House of Representatives. By 1840, Harrison had positioned himself as the leading Whig.

The general was welcomed with open arms in Alexandria, a Whig stronghold in an otherwise Democratic state. As it turns out, they had something to celebrate. During a meeting at Mechanics' Hall, party leaders announced that Harrison had won the election.

"This information was received with loud huzzas," reported the *Gazette*. "The White boys made old Mechanics' Hall ring with their shouts—a good specimen of what has before been termed Whig Thunder." The boisterous crowd made "repeated and loud calls" for *Gazette* editor Edgar Snowden to say a few words. Never one to disappoint, Snowden came to the stand and delivered a barnburner of a speech. Portraying "the corruptions of the fallen party" in "burning words," the Whig editor congratulated the Whigs on their "glorious victory."

"At the conclusion of his speech," Snowden's newspaper reported, "the Hall rang with shouts of applause."

Another speaker was a leading citizen from Westmoreland, revealing a sense of commonwealth in the District. "We felt proud that if not a part of Virginia, we were yet closely allied to her," the newspaper reported.

The Whigs organized a grand jubilee and illumination to celebrate their victory, a political celebration to an extent never been seen before

or since. Festivities included a parade of "different trades, occupations and professions," as well as a speech from George Washington Parke Custis. The procession was to march six abreast through the streets of Old Town, from Alfred to Prince up to Fayette to King to Washington to Duke and then back again. The parade was to culminate at "the South arch of the new Market House," where young ladies would represent the states and orators would deliver speeches.

"The Whigs of Alexandria will, each and all, on that occasion have WELCOME on their doors, and the string of the latch outside," according to a unanimously adopted resolution. "The people of Washington and Georgetown and the surrounding Counties in Virginia and Maryland, and all others, are invited to visit our town, and partake of our hospitality."

The day of the jubilee and illumination was "wet and disagreeable," according to the *Gazette*, but "the weather could not dampen the ardor of those who joined in the celebration." The air was filled with shouting during the parade as ladies waved handkerchiefs from the windows along the route. Ships along the waterfront were decorated with streamers and flags, and houses were outfitted with bunting. Sidewalks were filled with "lookerson," as the newspaper put it. George Custis, one of the city's best orators, delivered what the newspaper called "an eloquent, animated, and patriotic speech."

"It was a perfect gala day," the *Gazette* reported. "The most beautiful part of the procession was the open carriages filled with the little girls representing the States and Territories, all arranged in appropriate dresses, and bearing banners with the names of the States."

After the public ceremonies were over, Alexandrians continued to celebrate well into the night. Accounts of the festivities include references to "joyous visiting and hilarity," as well as "the generous juice of the grape." Hundreds of lights were lit for a grand illumination that filled Old Town with a glow that "would be utterly impossible for us to attempt a description." A large bonfire was lit on the waterfront, and music filled the air, as did "shouts and huzzas."

"More hearty, generous hospitality we never saw exhibited," the newspaper reported. "Sumptuous boards were spread in every direction, the string of every latch was on the outside, and welcome was on every tongue!"

A few days after the inauguration, Alexandria received a presidential visit, although not from the ailing Harrison. Instead the city received former President John Quincy Adams, a man who would have won over the city's voters twice if they had been allowed to vote for president. At that point, he had already served a decade in Congress, making him the only former president to serve in the House of Representatives. In his diary, Adams records a dinner with several Alexandria dignitaries followed by a speech at the Lyceum. "I delivered my lecture on Society and civilization to an aroused audience," Adams wrote, "after which there was a debate on the question of whether phrenology is a science useful to the community."

As the election of 1844 approached, the Whigs were enthusiastic about scoring another victory. "The fire of 1840 burned brightly," according to the *Gazette*. At long last, Henry Clay was on the ballot.

A native of Hanover County, Virginia, Clay remains one of the most divisive characters in American politics. As a young lawyer, he understood that moving west was a way to make a name for himself, so he settled his family in Kentucky and developed a reputation as an eloquent speaker

A satire published before the Democratic convention of 1844 predicting would-be presidential nominee Martin Van Buren's bath in the "Salt River," a colloquialism for political failure. *Library of Congress.*

with a quick wit and a sharp tongue. After he was elected to the House of Representatives in 1810, his colleagues in Congress chose him as Speaker on the first day. He would later become secretary of state and ultimately one of the most influential senators of all time. His speaking style was legendary.

"It had a wonderful flexibility and compass, at one moment crashing upon the ear in thunder-peals, and the next falling in music as soft as that of summer winds a-wooing flowers," explained one contemporaneous observer. "It rarely startled the hearer, however, with violent contrasts of pitch, and was equally distinct and clear when it rant out in trumpet tunes, and when it sank to the lowest whisper."

America may have been living in the Age of Jackson. But Alexandria was living in the Age of Clay—a man who stood in opposition to Old Hickory and formed a political party that called itself the Whigs to imply that Jackson was a tyrant on par with King George III. It was an argument that resonated in Alexandria, D.C.

"During the 1840 and 1850s, political life in Alexandria was dominated by the Whig Party," wrote city historian Michael Miller. "Composed of influential merchants and powerful politicians, the Whigs sponsored rallies, parades and barbeques."

In the spring of 1842, the Whig Party apparatus of Alexandria invited Clay to Alexandria. Although he could not attend, he sent an address to Alexandria leaders thanking them for the hospitality. He also took the opportunity to make sure the Whigs of Alexandria knew that he stood in solidarity with their plight.

"I have always regretted the existence of the anomaly, by which the Inhabitants of this District are deprived of any practical voice in the affairs of the Nation, whose seat of Government it is," Clay wrote. "It is a privation for which I trust some adequate remedy will be ultimately found. In the meantime, I take pleasure in bearing testimony to the manly character, the independence, and the patriotism which they have uniformly displayed amidst all the surrounding temptations."

The first mass meeting of the election of 1844 took place in October, when a lawyer by the name of A. Carey addressed the crowd.

"Mr. Carey's speech warmed up every Whig, and added to the zeal and determination of every friend of Henry Clay," the *Gazette* reported,

adding that "the speaker concluded amidst peals of applause" and "Whig thunder."

Unlike earlier campaigns, this contest featured dueling liberty poles in Alexandria. The Democrats erected one 124 feet high, which the newspaper described as "surmounted with a rooster." The Whigs responded by setting one up on King Street. It was described as "the loftiest and most beautiful Liberty Pole in all this section of the country." It was 212 feet high and featured an American eagle at the top that had been carved by local artisan Charles Green. An American flag flowed from the masthead, and streamers with the names Henry Clay and vice presidential candidate Theodore Frelinghuysen adorned it.

"Although a tree does not stand so high above the ground as the Whig Pole erected a short time after, yet it will vie with it in beauty and reflect a glorious contrast," one letter to the editor proclaimed. "The one in the noblest of the forest, while the other is emblematic of the great embodiment of that party, it being of a condemned mast."

Expressing the feelings of many Alexandria voters, the letter writer described James K. Polk as having "a bitter and uncompromising hostility to your best and dearest interests." As a member of the House, the letter

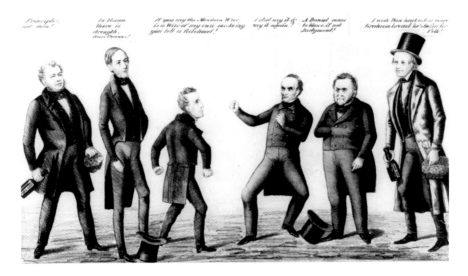

An indignant James K. Polk takes issue with Massachusetts Senator Daniel Webster's public attacks on his Texas policy. *Library of Congress.*

writer pointed out, Polk voted against relief for Alexandria after the Great Fire of 1827. Then he voted against the Alexandria Canal Company. After that, he voted against the bill aiding the city of Alexandria in the construction of the canal. Finally, he voted against the bill to incorporate the Alexandria Savings Company.

"I have no room to demonstrate the true friendship of Henry Clay for the people of the District of Columbia," the correspondent explained. "Let it suffice to say, that the first speech he made in Congress, in December 1806, was in favor of the erection of the bridge over the Potomac at Georgetown."

But the Democrats were not willing to give in without a fight. During a mass meeting in Alexandria, party leaders planted "a splendid Hickory Tree" on Royal Street in honor of Polk. The tree was festooned with a likeness of the presidential candidate, banners, wreaths and "principles of the Democratic party." Houses opposite of the tree were illuminated, and the windows and doors were filled with ladies.

"The tree does not stand so high above the ground as the Whig Pole," noted the *Gazette*. "Yet it will vie with it in beauty."

Clay, who had once delivered an hour-long speech on the Senate floor dedicated to his dead bull, Orozimbo, was seen as "a son of old Virginia" by people who could remember a time when Kentucky was a county of the commonwealth. At an early November rally, the Whigs of Fairfax County gathered to encourage supporters to "resist and defeat" the "enemies of the gallant Henry Clay." Noting that Democrats were trying to build support in Fairfax, Whig leaders implored the party faithful "to do honor" to the county. "Let it come with a loud tone for Clay and Frelinghuysen," the newspaper declared. "On to the polls."

Clay swept Fairfax County, although Polk won the election. Whigs described their defeat as a coalition of questionable forces. "Ultra Texas men at the South, protection in Pennsylvania, free trade in Alabama, religious prejudice in Maine, Mormonism in Illinois and foreigners everywhere," the *Gazette* observed. "But there was another feature introduced into the contest…the abominable doctrine…that there are two distinct classes in society, opposed to each other…the poor and the rich, and that it is the duty of the former to band together and vote against and overpower by their numbers the latter."

YEAR OF PROMISE

1846 and the Liberation of Alexandria

The seeds of failure that came to fruition in the 1840s were planted long before Alexandria became part of the district. In fact, the story dates back to 1780s, a time when the group of men who would later be known as the Founding Fathers met in Philadelphia.

Little could they have known how much they botched the creation of the District of Columbia. Perhaps the biggest mistake was granting Congress exclusive jurisdiction of the seat of national government. Yes, that's the same Congress that thought it was a good idea to invade Canada and extend slavery into the territories. No wonder it failed. It was doomed from the start.

Alexandria and Georgetown were both centers of a vast and thinly settled hinterland. They both depended on a vibrant shipping business with all the associated commercial and financial activities. Perhaps more importantly, they were bitter rivals. Both viewed the opportunity to become part of the newly created District of Columbia as a way to get ahead of the other. But this was to be a zero-sum game for the sister cities, one that created a rift in the family that would eventually lead to divorce. None of that was evident at the outset, although there was a hint of bad weather on the horizon. "There was one cloud in the sky," wrote

The United States Capitol in 1846. *Library of Congress.*

the late historian Bill Hurd. "The District of Columbia failed to provide either for territorial self-government or for representation in Congress."

In truth, it took the storm clouds decades to gather. The reluctance to abandon the failed experiment was delayed by a prevailing belief at the time, founded in the history of Europe, that national capitals were great financial, commercial and industrial centers. Yet Alexandria residents became disillusioned by the interminable wait for any developments in that direction. Instead, they faced a prohibition against the erection of public buildings for the general government south of the Potomac. Then there was the dislocation of trade patterns resulting from the Embargo and Non-Intercourse acts and the War of 1812.

As the enmity between Alexandria and Georgetown grew during the first half of the nineteenth century, it seemed that Congress always preferred to side with the former at the expense of the latter. Alexandria's economic aspirations were doomed, and so it became

increasingly clear that Alexandria, D.C., would remain a handmaiden to Georgetown and Washington.

Strangely enough, the first rumblings toward retrocession began in Georgetown. As early as 1801, residents of Georgetown, D.C., were angling to get out. Over time, though, it was the folks in Alexandria who took up the banner. Year after year, the effort gained force. The first attempt at retroceding Alexandria back to Virginia took place as early as 1804, just as the city charter was finally making its way through Congress. It failed, but it led to future attempts in 1808 and 1832.

The first serious effort to retrocede began with a mass meeting at the town hall on Tuesday March 9, 1824. According to an account of the meeting in the *Alexandria Gazette*, more than 150 people attended. Alexandria city councilman Thomson Mason of the Third Ward was elected chairman of a committee charged with drafting a memorial to Congress soliciting the restoration of Alexandria to the commonwealth of Virginia. The group also designated four people in the city and four people from the county to circulate the memorial, essentially acting as public relations agents to sell the message; Alexandria wanted out of the "ruinous evil" that was the District of Columbia, with retrocession serving as "a remedy of the past, and a hope for the future."

"It is earnestly hoped that this intelligent and patriotic," Mason wrote, "but depressed and proscribed portion of the American family, will respond cordially to so momentous and appeal to its understanding, its feeling and its interests."

But opposition was already brewing. The next item in the *Gazette* that day was an anonymously written paragraph urging readers to "suspend giving their signatures" to the memorial in favor of retrocession. Instead, explained "A Citizen," readers should wait to consider a counter memorial. In a letter to the editor of the *Gazette*, Mason described the opponents of retrocession as "vigilant, active and dexterous." Apparently, he was right because the referendum failed by a vote of 404 to 286.

In 1832, the citizens of Georgetown successfully lobbied Congress to kill a bill that would have helped the city of Alexandria by financing the extension of the Chesapeake and Ohio Canal from Georgetown to

Alexandria. That delayed the extension by more than a decade, a time when retrocession fever was building.

One of the most promising attempts at retrocession took place in 1838, when Virginia Democrat Henry Wise offered a resolution "to inquire into the expediency of receding, under proper instructions and reservations, with the consent of the people of the District, and of the States of Maryland and Virginia, the said District to the States." That resolution passed the Committee on the District of Columbia. Meanwhile, the Maryland Senate passed a resolution supporting retrocession of the Maryland portion of the District of Columbia, which was followed by a petition to Congress "praying for a retrocession."

After the legislation was considered in the Committee of the District of Columbia, Chairman James Bouldin—a Virginia Democrat—reported to the House that the committee voted to recommend "against the expediency of retrocession." Congressman Wise took to the House floor and delivered a speech arguing that if the House and Senate were allowed to vote on the matter "a majority of Congress would be found to differ with the District of Columbia Committee."

Wise also made a salient point about the influence of slavery on the issue, one that lurked beneath the surface for most of the debate but was nevertheless an important motivation. The congressman pointed out that the antislavery faction in the committee opposed retrocession in anticipation of one day abolishing the trading and holding of slaves in the District of Columbia.

The hidden history of why Alexandria wanted to retrocede may have been shackled to the basement of the slave-trading operation on Duke Street. As the tobacco and wheat trade declined during the 1830s, slavery became one of the city's dominant businesses. Economic sustainability was chained in human bondage in an institution that created a sense of uneasiness. The real story may have been what went largely unsaid during the debate on retrocession.

"Lying close to the surface, but only rarely breaking out into view," explained Alexandria historian William Hurd, "was the slavery issue." Hurd pointed out that Alexandria was concerned that the slave trade could be abolished in the District of Columbia, a fear that was justified

considering that's exactly what happened in the Compromise of 1850. Considering the central place of the peculiar institution in the city's economy, the threat of abolition posed a financial danger. Meanwhile, planters in eastern Virginia were concerned that the District would become a mecca for runaway slaves.

Just as the slavery issue was heating up, so was the movement for retrocession. Yet there was a host of issues that led to the growing popularity of leaving the District of Columbia. One was the financial crisis that developed after President Andrew Jackson vetoed the bill that would have rechartered the Second Bank of the United States. In the midst of the crisis, Alexandrians complained that Congress was neglecting their needs, particularly citing the reluctance to assist in the financing of a sewage system. And the lack of voting representation was the ever-present ghost haunting the debate. The Alexandria City Council adopted petitions asking Congress to return to Virginia in 1841 and then again in 1846.

The capitol building of Virginia in Richmond. *Library of Congress.*

The Virginia General Assembly finally got into the act on February 2, 1846, setting in place a series of events that would finally lead to a divorce between these two mismatched spouses. The effort was styled "An Act accepting the State of Virginia, the County of Alexandria, in the District of Columbia, when the same shall be receded by the Congress of the United States." Later that month, on February 25, 1846, the House Committee on the District of Columbia reported House Resolution 259 to the Twenty-ninth Congress. The bill essentially provided for the retrocession to Virginia of the area ceded in 1801. It also provided for the courthouse and the jail to be conveyed to the governor of the commonwealth and stipulated that Congress would not assume the debt of the town. A committee from the town of Alexandria submitted a strongly worded report that accompanied the resolution.

"The experience of more than forty years," proclaimed the report, "seems to have demonstrated that the cession of the county and town of Alexandria was unnecessary for any of the purposes of a seat of government, mischievous to the interest of the District at large, and especially injurious to the people of that portion which was ceded by Virginia."

The report included a number of reasons why the Congress should act favorably on the legislation. First of all, the part of the District north of the river had more than enough room for all of the public buildings that were likely to be built, at least in the short term. Then there was the excessive territory of the District, which was clearly a burden to the Congress. Don't forget about the patchwork of Virginia and Maryland code that created havoc in the court system, a problem that was exacerbated by the failure of Congress to harmonize the various rules or even keep them up to date. And residents of the District were denied the right to have representation in Congress or vote for a presidential candidate.

"A foreigner, on reaching some distant portion of our territory, might well expect, on approaching the seat of government, to find its inhabitants enjoying in at least an equal degree the free institutions of the county," explained a committee of prominent Alexandrians in an 1846 letter to Congress supporting retrocession. "In ascertaining *our true* condition, how unaccountable must it appear that *we alone* are denied them!"

Ultimately the bottom line was, as always, money. Appropriations were made to Washington, D.C., and Georgetown, D.C. But Alexandria, D.C., proved to be the redheaded stepchild of the District of Columbia. According to one account, the entire amount of appropriations to Alexandria during the half century it was part of the District of Columbia was about $920,000—and most of that was for the canal. Exports, imports and tonnage at the port had been in a state of decline since 1815, and the population had been stagnant since 1820. Many Alexandria businessmen were still angry about the federal government's decision to block the channel between Alexandria and the upper Potomac.

Opponents of retrocession included John Quincy Adams, the former president who was then serving as a National Republican member of Congress. He and others argued that retrocession would set a dangerous precedent to the dissolution of the Union. We now know that this was a justified fear, although not because of the precedent that was set in this case. Another argument that was marshaled against retrocession was that it was unconstitutional, breaking an agreement that was brokered in the hot summer of Philadelphia in 1787 and immortalized in Article 1 Section 8 of the Constitution.

Supporters of retrocession dismissed the argument that allowing part to leave the District of Columbia was unconstitutional, contending that Congress had the same power to create that it had to destroy. Added to that was the fact that James Madison moved to strike out the word "permanent" from the act establishing the seat of government because the Constitution did not contain it.

"The entire power of the general government over the immense body of public domain acquired by the cession of Florida and Louisiana has never been doubted, and that obtained by the recent annexation of Texas must occupy a similar footing," explained a group of prominent Alexandrians in a letter to Congress supporting retrocession. "We are a useless and burdensome appendage to the general government."

The argument for retrocession always began with a proposition that the District of Columbia was just too darn big. Advocates for returning Alexandria to Virginia said the federal government would be wasting time and money by having a capital city that exceeded the necessary size.

Furthermore, they argued, keeping Alexandria in the District deprived voters of representation in Congress—a familiar argument even today. Other than Congressman Wise's speech in 1838, slavery was never part of the public discussion on the issue, but it was nevertheless looming in the shadows.

On May 7, 1846, the bill was made a special order of the day for House floor debate. Managing the debate was a Virginia Democrat who was the chairman of the District of Columbia Committee: Robert Mercer Taliaferro Hunter, who represented Virginia's Eighth Congressional District. At the end of the debate on the bill, which stretched into a second day, Hunter took to the floor of the House of Representatives to deliver a stirring speech in favor of retrocession. The outline of the speech was designed to tug at the heartstrings of democracy, specifically calling attention to the lack of representation in Congress by the people of Alexandria.

"I know of nothing better calculated to debate public character than to train a people to believe that they must depend upon secret arts and indirect influence," said Hunter. "Who can estimate the probable ills of the sort of influence which they will exercise over the government?"

Hunter would later become a senator from Virginia and ultimately a secretary of state for the Confederate States of America. But for now, the congressman told his colleagues that transferring Alexandria to Virginia would be advantageous to the District of Columbia. Noting what he called a "sectional opposition" between the two sides of the District, he said the people in the two portions are as "divided as the Potomac [that] divides them."

"They live under different codes of laws, one founded on the Virginia and the other on the Maryland system of laws, as they existed at the time of cession," he said. "All attempts to harmonize these systems with each other have hitherto failed, and Congress have not had the time or means of establishing a new code which might be uniform or satisfactory to both."

Had Alexandria remained part of the commonwealth, Hunter speculated, Alexandria would have been "a flourishing depot of commerce." But this is not what happened. Instead, the congressman

Artist Augustus Kollner's view of Washington, D.C., looking northwest. *Library of Congress.*

explained, Alexandria had been separated from Virginia "in an evil hour" and treated "like a child separated from the natural and neglected by the foster mother." Hunter described the Alexandrians as "our brethren," and implored Congress to take action returning the long-neglected part of the District of Columbia back to the commonwealth of Virginia.

"Go look at her declining commerce, her deserted buildings and her almost forsaken harbor," Hunter concluded. "Let us pass this bill and either you nor they will ever repents of it, but on the contrary, you will receive for it the blessings not only of themselves but of their most distant posterity."

Alabama Democrat William Payne suggested that the slave areas of eastern Virginia supported retrocession in order to gain voting advantage of the nonslaveholding counties of western Virginia. As a result, he recommended that the bill be amended to require a referendum throughout the District of Columbia on the proposal—and that males "other than white" be permitted to participate. The amendment failed, but here again the issue of slavery was lurking just beneath the surface of the debate.

Payne and two other colleagues on the committee voted against the bill, although significant support from Pennsylvania and New York swang the vote in favor of retrocession. The House approved the measure on a roll

call vote of ninety-six yeas and sixty-five nays. Among the House members who voted for retrocession were future president Andrew Johnson and future Confederate vice president Alexander Stephens. House members to voted against retrocession included future Confederate president Jefferson Davis and future vice president Hannibal Hamlin.

When it reached the Senate, the bill was referred to the Senate Committee on the District of Columbia. Chairman William Haywood, a Democrat from North Carolina, reported the House-passed bill "for the retrocession of the city and county of Alexandria with a recommendation that it be rejected." The bill was debated on the Senate floor on July 2, 1846, when Chairman Haywood argued that retrocession was unconstitutional. Committee member Senator Jacob Miller, a Whig from New Jersey, also made this point, adding that "a great number of citizens of the county, being out of the city of Alexandria, were opposed to the retrocession." But it was in vain, and the Senate passed the measure by an overwhelming margin—thirty-two yeas to fourteen nays. Among the senators voting in favor of retrocession was South Carolina firebrand John C. Calhoun and Florida Democratic Senator James Westcott Jr., who was born in Alexandria, where his father was a newspaperman and a politician.

The long struggle culminated on July 9, 1846, when President Polk signed "An Act to retrocede the County of Alexandria, in District of Columbia, to the State of Virginia." The act provided that "all of that portion of the District of Columbia ceded to the United States by the State of Virginia."

"No more territory ought to be held under the exclusive legislation given to congress over the district which is the seat of the general government than may be necessary and proper for the purposes of such as seat," the act proclaimed. "Experience hath shewn that the portion of the District Columbia ceded to the United States by the state of Virginia has not been, nor is ever likely to be, necessary for that purpose."

The act was to be in force after "the assent of the people of the county and town of Alexandria…and on the day so appointed, every free white male citizen…who shall have resided in said county for six months… insane persons and paupers excepted, shall vote *viva voca* upon the question of accepting or rejecting retrocession to Virginia."

President Polk appointed Robert Brockett, George Custis, George Smoot, George Ramsay and James Roach as commissioners. They were entrusted with orchestrating the referendum, and notice of the vote was published in the *Alexandria Gazette* and the *Southern Churchman*.

After decades of waiting, the retrocessionists finally had their day at court.

RETROCESSION SONG

Come Retrocessionists, give a loud shout,
Hurrah! We'll retrocede,
And show the anti's what we're about,
Hurrah! We'll retrocede.
For freemen's lives we are bound to lead,
And to Virginia retrocede;
The ladies all cry out, "God speed,"
Hurrah! We'll retrocede.
Let dollars and cents deter us not,
Hurrah! We'll retrocede.
Let freemen's rights never be forgot,
Hurrah! We'll retrocede.
For freemen's lives, &c.

Come about for——, firm, tired, and true,
Hurrah! We'll retrocede.
For——,——,——, and——too,
Hurrah! We'll retrocede.
For freemen's lives, &c.

Here's to the ladies, whate'er they say,
Hurrah! We'll retrocede.
To Retrocession, they cry out "O.K."
Hurrah! We'll retrocede.
For freemen's lives, &c.

Now for Retrocession give three loud cheers,
Hurrah! We'll retrocede.
And make the anti's shed a few tears,
Hurrah! We'll retrocede.
For freemen's lives we are bound to lead,
And to Virginia retrocede.
The ladies all cry out, "God speed,"
Hurrah! We'll retrocede.

Originally published in the September 2, 1846 edition of the Alexandria Gazette.

RETURN TO THE COMMONWEALTH

Alexandria Leaves the District of Columbia

Just as September ushers in autumn, voters swept out the District like so many dead leaves. Their bloom was once promising in the age of Jefferson. But the age of Jackson had seen significant deterioration followed by economic strains as the captains of industry sailed to other ports. The equinox had arrived at last for the retrocessionists gathered in Market Square. The first two days of September 1846 were set aside to make sure people from the city and the county had enough time to travel to and participate in the referendum.

"Every free white male citizen who has resided in the Town or County for six months past is a voter," the *Alexandria Gazette* explained.

The year of promise had finally arrived, and a crisp autumn breeze marshaled a sense of brisk excitement. The time had arrived. As the September afternoon grew late, a gang of retrocessionists gathered to march in procession through the streets, with flags, musicians and a cannon that was fired intermittently.

Alexandria Mayor William Veitch cast the first vote, a ballot he cast in favor of retrocession. "Several exquisite serenades were given, and the song and the toast went round from street to street and from house to house," the *Gazette* reported. "At night, a torch light procession was

Mayor William Veitch cast the first vote for retrocession. *Brandy Crist-Travers*.

formed, a brilliant bonfire was lighted, and our streets were filled with citizens congratulating each other."

At the end of the first day of voting, the clerk announced that the tally so far was 633 in favor of retrocession and 197 against. Clearly, the tide was with the retrocessionists, although nobody was counting out a last-minute surge of voters or underhanded politics. According to one account in the *Gazette*, Alexandria practically shut down as the balloting went into its second day. Polls were open from 10:00 a.m. to 6:00 p.m.

"The neighborhood of the Court House presented a lively scene, while the other parts of the town were comparatively deserted," the *Gazette* reported on September 2. "Many of the stores were closed, and business seemed to be generally suspended."

The final vote was more than three to one in favor of retrocession, with 763 in favor of retrocession and 222 against. Interestingly, four of the five commissioners appointed by President James K. Polk voted for retrocession; George Custis did not vote. (Remember that all votes were *viva voca*, and the list of who voted for what is part of the public record.) Those who voted against the referendum tended to be from the country part of Alexandria, an area now known as Arlington, where immigrants from Pennsylvania and New York brought improved agricultural methods and an increased level of prosperity.

The announcement of the final tally, according to the *Gazette*, "was received with the loudest cheers, and a salvo from the artillery." The night air was rent with bands of young men singing "patriotic songs, having reference to the event just accomplished." The procession was dismissed before nightfall "in the highest spirits." As soon as the September night fell, people began to assemble "in an around the public square *en masse*." The "young folk" lit their torches as the "flambeaux, flags, banners and transparencies were produced." The cannon thundered as the "fire arms of all kinds were discharged." Festivities included "rockets, squibs and crackers" that were let off with "the general joy and enthusiasm." That was followed by a round of speeches.

"As soon as the speaking was over," the *Gazette* reported, "the crowd formed in procession and marched through the principal streets, crossing the *old line* which used to divide us from Virginia, and, upon the soil of our State, firing a National Salute, in honor of RETROCESSION."

"We welcome Alexandria back to the family circle," proclaimed the *Fairfax News*. "To those who showed so great an aversion to nestling again in the bosom of their old mother, we extend the hand of friendship, and trust that their fears will vanish like mist before the rising sun."

On September 7, 1846, President Polk issued a proclamation of the result of the poll and declaring the act was "in full force and effect." Yet this was not the end of the story, at least not yet. The act of Congress stipulated that the "jurisdiction and laws now existing in the said territory…shall not cease or determine until the state of Virginia shall hereafter provide by law for the extension of her jurisdiction and judicial system over the said territory hereby receded."

The problem with this is that the Virginia General Assembly would not convene until January. Governor William Smith included a passage about retrocession in his annual December message to legislators on the eve of their session. "Every preliminary condition and formality has been strictly observed," the governor told assembly members. "Nothing now remains to effectuate the retrocession of the said county but for you to provide by law for the extension of our jurisdiction over it."

That prompted a lengthy debate and several joint conferences between the state Senate and the House of Delegates. At issue was the tenuous political balance between the aristocracy of the eastern Tidewater and the newer settlements of the Blue Ridge. On March 13, 1847, the Virginia General Assembly finalized the arrangement with a bill returning Alexandria to Virginia. In the first telegram ever sent from Alexandria, officials wired to Baltimore from Washington that "under the genial influences of her good old mother Commonwealth to whom she has so lately returned, after so long an absence, the roses are returning to her cheeks and she is fast recovering the health elasticity of her early youth."

A few days later, a writer using the name "Anti-Mercator" spelled out the reasons for opposing retrocession. For one, he said, it was unconstitutional. A second reason was that it would raise taxes, a surefire argument if there ever was one. Then there were a host of ancillary reasons. People seeking to appeal court rulings or admiralty court proceedings would have to travel all the way to Richmond. Banks would be taxed by the General Assembly and probably be forced to pay a bonus to renew their charters. Furthermore, Anti-Mercator explained, Alexandria would lose out by being represented by young and inexperienced members of the General Assembly and a sluggish Virginia court system.

As for the key argument of those in favor of retrocession—that Alexandria could snag Congressional representation—Anti-Mercator was dismissive. "What advantage will this be to a large majority of the people of Alexandria?" he asked. "Not more than from 3 to 400 out of about 10,000 inhabitants of the town and county will have a right to vote."

In other words, the restrictive franchise of who was allowed to vote was used as an argument against Congressional representation. Why

bother, Anti-Mercator asked, when the vast majority of people wouldn't be allowed to participate anyway. It would seem the list of arguments was designed to build a coalition of sorts—bankers, women, lawyers, free blacks, seamen and renters. If the city became part of Virginia again, taxpayers would be on the hook for funding internal improvements and contributing to the library fund. It's a series of arguments that seem to have carried the day.

"We are happy in being able to assure our readers," wrote *Alexandria Gazette* editor Samuel Snowden on March 30, "that not only a majority of the Committees of both Houses but four-fifths of the Members themselves are decidedly opposed to the mentioning of Retrocession."

But the debate continued. On April 1, 1824, the *Gazette* published a letter from "An Alexandrian" arguing that retrocession was unconstitutional. Essentially, he maintained, the Constitution gave Congress the power to accept territory but not the power to give it back. The language in the constitution seems pretty clear about establishing a "permanent" seat of government "not exceeding ten miles square." Having done this, An Alexandrian noted, Congress is bound to retain the whole of the ten square miles for the permanent seat of government. "They have no more power to *contract* its limits than they have to *extend* them," opined the writer. "Congress cannot now undo what they have done any more than they can exclude a new state from the Union after it has been admitted."

Even if Congress had the power to give up part of its territory, An Alexandrian wondered, it was unclear whether or not Virginia had the power to add to its commonwealth. To make this point, he recalled the 1789 act of cession, which *forever* ceded the county of Alexandria in *full* and *absolute* and *exclusive* jurisdiction. It's a point that has lingered over the years.

It didn't take long for people to start forgetting that Alexandria had ever been part of the District of Columbia. The Congressional Directory is full of references to people who were technically born in the District of Columbia when it included Alexandria, even if their place of birth is listed as Virginia. The list includes James Pearce, who served as a congressman and senator from Maryland; Richard Stanton, who served as a representative from Kentucky; and his brother, Frederick Perry

A grandiose campaign print designed for the 1848 presidential campaign of Zachary Taylor. *Library of Congress.*

Stanton, who served in Tennessee's lower house. And let's not forget that Robert E. Lee married his wife at the Arlington House when it was part of the District of Columbia, not Virginia.

Instead of simply returning Alexandria to Fairfax County, the act created the county of Alexandria and designated the city as the county seat. New seats were created in the General Assembly and Congress, finally allowing city residents to have representation once again. But there was another important benefit to becoming part of Virginia: participating in presidential politics.

The first presidential election after retrocession took place in a year when Whigs were once again on the ascent. Indian-killer Zachary Taylor, known to supporters as "Old Rough an' Ready" was the standard-bearer for the Whigs, while former Secretary of War Lewis Cass emerged as the candidate of the Democrats. Unsurprisingly, the Whigs ticket was very popular in Alexandria.

A group calling itself the Taylor Whig Club began organizing in September, with meetings at Liberty Hall featuring speeches by prominent

Edgar Snowden. *Alexandria Association.*

Alexandrians and performances from a glee club that performed "some of the best Whig songs." The first meeting featured the "Whig ladies of Alexandria" presenting a banner to the club inscribed with what the *Alexandria Gazette* described as "mottoes and devices appropriate to the present Presidential campaign."

The newly enfranchised Alexandrians were eager to part of the process. The Whigs designated a delegation of thirty individuals to attend a state convention in Lexington on September 27, 1848, a group that included *Gazette* editor Edgar Snowden. The Rough and Ready Club acquired a "handsome silk banner" to advocate for the Whig candidates.

This was an era of soaring oratory, and newspaper coverage of city politics featured summaries of speeches that were delivered to partisan audiences. There was Lawrence Taylor, who delivered an excellent speech "both in matter and manner" that was "sound in doctrine and correct in principle." Then there was Philip Fendall, who delivered an address on the abuse of the veto power. The *Gazette* also reported on a Maryland lawyer named Charles Stuart, who delivered "a spirited speech, full of animation and cheering sentiments." During one Democratic Party meeting in Alexandria, the oratory soared for more than five hours before the meeting adjourned with "three tremendous cheers for Cass, Butler and democracy."

The campaign featured a familiar divide between urban Alexandria City, which supported Democrats, and rural Alexandria County, which supported Whigs. In October, an organization billing itself as the Rural Cass and Butler Association near Balls' Crossroads organized a barbecue and grand rally. Not to be outdone, the Taylor Whig Club put together a parade beginning at Union Street and marching up Cameron Street.

That political divisions ran deep was evident during the Whig parade through the streets of Old Town. According to an account in the *Gazette*, "a band of rowdies, armed with bludgeons" threw stones at the crowd and "attempted to insult and annoy their political opponents." In an editorial about the melee, Snowden observed that it would be "unjust to blame the party for these rowdies." Nevertheless, he noted, people who engage in such behavior must expect to take the consequences. "Let them look out," Snowden warned. "They may catch it before they think their come is come!"

Alexandria's first real presidential campaign in two generations culminated in a torchlight procession, which was described as similar to "the glorious times of 1840 all over again." Whigs turned out in force, packing the streets with banners, flags and signs. Musicians positioned at intervals along the route played "patriotic airs" as "dense crowds" moved through the streets and onto the sidewalks. Ladies waved handkerchiefs and houses were illuminated. Ultimately, the parade culminated at Liberty Hall, where a series of speeches capped off the night.

"At the close of speaking, the enthusiasm of the meeting was expressed by cheer after cheer and the adjournment took place amidst a storm of applause bestowed upon the orators who had so highly gratified the Whigs there assembled," the *Gazette* reported. "During the evening, at the arrival and departure of the Boats, sky rockets and Bengola lights were displayed."

That election set the stage for the Compromise of 1850, which finally brought an end to slave trading in the District of Columbia, confirming the fears of many Alexandria businessmen who supported retrocession. Yet Alexandria was able to continue its peculiar institution because it was now once again part of the slave-trading commonwealth of Virginia.

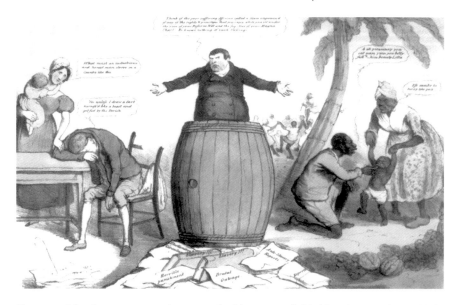

Slavery and freedom are contrasting scenes in this cartoon divided by a huge cask on which stands an obese preacher. *Library of Congress.*

"Had Alexandria remained part of the District of Columbia, Alexandria's slave-trading operations would have had to move to a less advantageous central location," wrote historian Nelson Rimensnyder. "Alexandria's location and port facilities made the city an important link in the slave-trade with New Orleans and Mississippi River ports."

Epilogue

The Rest of the Story

The debate about retrocession did not end in 1846. In some ways, it continues today.

The first protest was filed days after the retrocession. A group of dissidents in rural Alexandria County filed a protest with the Virginia General Assembly claiming that the whole scheme had been planned in what the men described as "a secret meeting." Their protest also described the General Assembly's enabling legislation as "beyond the possibility of honest doubt, null and void." The complaint was quickly dismissed, but it would not be the last time retrocession was questioned.

Thirty years after Alexandria was returned to Virginia, the matter was debated in the Supreme Court of the United States of America, a body that was then located in the old Senate chamber of the Capitol. The 1875 lawsuit was filed on behalf of a citizen of Alexandria County against the tax collector specifically to test the constitutionality of the issue in case known as *Phillips v. Payne*. The defendant was a large landowner in Alexandria County who was unhappy with a property tax assessment of $164.18. So he brought a suit against the tax collector, charging that Alexandria was not within the jurisdiction of Virginia.

"The United States Supreme Court avoided the issue by declaring that retrocession was a political act," wrote historian Robert Scribner. "A private citizen could not raise the issue."

Writing for the majority, Justice Noah Haynes Swayne suggested that serious consequences would follow a ruling for the plaintiff. Taxes would have been illegally assessed and collected, the election of public officers would have been without warrant of law, public accounts would have been improperly settled and decrees of the court would have been nullities; those who carried them into execution could be held criminally liable.

"Both parties to the transaction have been and still are entirely satisfied," Swayne wrote. "No murmur of discontent has been heard from them."

Interestingly, the court sidestepped the issue of whether or not retrocession was constitutional, rendering a decision that the United States and the commonwealth of Virginia were both willing participants to the act. Furthermore, the justices ruled, both of the parties involved had long acquiesced in the transfer of the county without objection or protest. Essentially, they decided that an individual did not have standing to challenge the constitutionality of retrocession. "He cannot, under the circumstances, vicariously raise a question nor force upon the parties to the compact an issue which neither of them desires to make," Swayne concluded.

A generation later, in 1902, Michigan Republican Senator James McMillan introduced a resolution directing Attorney General Philander Knox to bring a lawsuit to determine "the constitutionality of the retrocession." The resolution declared that it was "desirable that the city and county of Alexandria should be returned to the control of the government of the United States." The resolution was referred to the District Committee, although the unexpected death of McMillan in August 1902 brought the issue to a close.

But the debate continued. In 1910, Montana Republican Senator Thomas Carter launched an unsuccessful campaign in to solve what he called the "Crime of '46." Then in 1915, former President William Howard Taft wrote a *National Geographic* article in which he called

retrocession the work of "little Americans" who "minimize everything national," describing it as an "injury" and "egregious blunder" that he wanted to fix. "While I was in the White House I conferred with Representatives of Virginia in the House and Senate to see whether we might not procure some legislation by the State of Virginia tendering back all or a part of that which had been retroceded," Taft wrote. "I found that since Alexandria had grown in to a prosperous city Virginia would never willingly part with it."

Meanwhile, tensions mounted between Alexandria City and Alexandria County. Ever since the county acquired its own courthouse in 1898, the county began forming its own sense of community separate from Alexandria. The conflict between city and county grew more pronounced as city leaders began making efforts to annex parts of tax-rich Potomac Yards, a major railroad freight switching facility. By the early twentieth century, the neighboring jurisdictions were ready for a symbolic divorce. In 1920, the General Assembly adopted an act declaring from thenceforth the county that had been "known and designated as Alexandria County shall hereafter be known and designated as Arlington County."

"The name was chosen to honor Gen. Robert E. Lee, who for so many years had made his home at Arlington House," wrote Arlington historian C.B. Rose. "The change was made to eliminate the confusion resulting from a city and a county with the same name."

Across the river, the debate about a lack of representation in the District of Columbia obviously continues today, although voters there have had some success. They won the right to vote for president in 1961, and they got a nonvoting delegate to the House of Representatives in 1970. Then there was limited home rule in 1973. When Congress considered statehood for the District in 1993, the idea of retrocession briefly gained some traction, although the effort to create the state of New Columbia lost by sixty-three votes.

"Debates over retrocession in the District of Columbia began in the months following Congress's arrival to Washington in 1800, climaxed with the successful retrocession of Alexandria to Virginia in 1846, revived as Washington attempted to deal with growth and development at the

turn of the twentieth century, and cooled during most of the twentieth century," wrote Washington sociologist Mark David Richards. "However, the idea remains alive today as one possible solution to winning the same political and economic rights enjoyed by citizens living in states, along with the more popular proposals for equal voting rights in Congress coupled with a secure form of local self-government or statehood."

BIBLIOGRAPHY

Alexandria Gazette. "Distressing Fire." September 26, 1810.

————. "Fire…And Local History." Special section, October 8, 1974.

————. "The Late Fire." January 23, 1827.

Alexandrian 3, no. 3. "The Great Alexandria Fire—1827" (March 1977).

Artemel, Janice, Elizabeth Crowell and Jeff Parker. *The Alexandria Slave Pen: The Archeology of Urban Captivity.* Washington, D.C.: Engineering-Science, Inc., 1987.

Boller, Paul. *Congressional Anecdotes.* New York: Oxford University Press, 1991.

————. *Not So! Popular Myths About America From Columbus to Clinton.* New York: Oxford University Press, 1995.

Bordewich, Fergus M. *Washington: The Making of the American Capital.* New York: HarperCollins, 2008.

Carne, William. "Life and Times of William Cranch, Judge of the District Court, 1801–1855." Vol. 5. Records of the Columbia Historical Society, Washington, D.C., 1902.

Cone, Edward. *Some Account of the Life of Spencer Houghton Cone, a Baptist Preacher in America.* New York: Livermore & Rudd, 1856.

Cressey, Pamela. "Council Saved City Through 1812 Surrender." *Alexandria Gazette Packet,* July 3, 1996.

Deines, Ann. "The Slave Population in 1810 Alexandria, Virginia: A Preservation Plan for Historic Resources." Thesis submitted to the Columbian College at the George Washington University in Washington, D.C., 1987.

Di Giacomantonio, William C. "All The President's Men: George Washington's Federal City Commissioners." *Washington History* 3 (Spring/Summer 1991).

Eggerz, Solveig. "City Slave Trader Was 'Best of a Bad Breed.'" *Alexandria Port Packet*, November 19, 1980.

Finkelman, Paul, and Donald Kennon, eds. *In the Shadow of Freedom: The Politics of Slavery in the National Capital.* Athens: Ohio University Press, 2011.

Fireside Sentinel 2, no. 5. "Two Impetuous Young Men: The Cazenove-Fowle Duel."

Hahn, Thomas Swiftwater, and Emory L. Kemp. *The Alexandria Canal: Its History and Preservation.* Morgantown: West Virginia University Press, 1992.

Hare, Dunbar. "First Trial in District Found to be Rum Case." *Washington Post*, February 9, 1930.

Howe, Daniel Walker. *What Hath God Wrought: The Transformation of America, 1815–1848.* New York: Oxford University Press, 2007.

Howison, Robert Reid. "Dueling in Virginia." *William and Mary Quarterly* 4, no. 4.

Hurd, William. "An Act to Retrocede the County of Alexandria, in the District of Columbia, to the State of Virginia." Manuscript for the *Georgetowner* in possession of the Alexandria Library Local History Special Collections Department, n.d.

Hurst, Harold. "Decline and Renewal: Alexandria Before the Civil War." *Virginia Cavalcade* 31, no. 1 (Summer 1981).

Kelly, John. "Slave Trade and Alexandria's 'Retrocession.'" *Washington Post*, September 24, 2010.

Mann, Harrison. "Chronology of Action on the Part of the United States to Complete Retrocession of Alexandria County (Arlington County) to Virginia." *Arlington Historical Magazine* 1, no. 1–2 (October 1957).

Miller, Michael. *Alexandria (Virginia) City Officialdom, 1749–1992.* Bowie, MD: Heritage Books, 1992.

————. *If Elected: An Overview of How Alexandrians Voted in Presidential Elections from 1789 to 1984.* Alexandria, VA: Alexandria Library, 1984.

————. "A Letter From Henry Clay to the Whig Committee of Alexandria." *Fireside Sentinel* 8, no. 4 (July 1994).

————. *Murder & Mayhem: Criminal Conduct in Old Alexandria, 1749–1900.* Bowie, MD: Heritage Books, 1988.

————. *Pen Portraits of Alexandria, Virginia, 1739–1900.* Bowie, MD: Heritage Books, 1987.

————. *Portrait of a Town: Alexandria, District of Columbia, 1820–1830.* Bowie, MD: Heritage Books, 1995.

Nott, Edward. "The Revolution of 1800." *Alexandrian* 2, no. 8.

Pitch, Anthony S. *The Burning of Washington: The British Invasion of 1814.* Annapolis, MD: Naval Institute Press, 1998.

Powell, Mary G. *The History of Old Alexandria, Virginia.* Westminster, MD: Willow Bend Books, 2000.

Pratt, Sherman W. "Northern Virginia in the War of 1812." *Arlington Historical Magazine* 12, no. 2 (October 2002).

Proctor, John Clagett. "Retrocession of Alexandria County." *Sunday Star,* September 8, 1946.

Rimensnyder, Nelson. "Retrocession of Alexandria, 1846." Report of the House of Representatives 22-337, Serial 226, 7. Washington, D.C.

Rosania, Mary Ellen. "The 'Fire-Eater' and the General." *Northern Virginia Heritage* 4, no. 1 (February 1982).

Rose, C.B., Jr. *Arlington County, Virginia: A History.* Baltimore, MD: Port City Press, 1976.

Rothgeb, Roy. "An Analysis of the Rise, Decline and Possibilities for Redevelopment of the Port of Alexandria, Virginia." Thesis, City College of New York, 1957.

Scribner, Robert L. "In and Out of Virginia." *Virginia Cavalcade* 15 (1965).

Shenkman, Richard, and Reiger, Kurt. *One-Night Stands with American History.* New York: Quill, 1982.

Shomette, Donald G. *Maritime Alexandria: The Rise and Fall of an American Entrepot.* Bowie, MD: Heritage Books, 2003.

Skivora, Joseph. "The Surrender of Alexandria in the War of 1812 and the Power of the Press." *Northern Virginia Heritage* 10, no. 2 (June 1988).

Smith, William Francis, and Michael Miller. *A Seaport Saga: Portrait of Old Alexandria, Virginia.* Virginia Beach, VA: Donning Company Publishers, 1989.

Smoot, Betty Carter. *Days in Old Town.* Washington, D.C.: Judd & Detweiler, 1934.

Sunday Star. "Retrocession of Alexandria County." September 8, 1946.

Sweig, Donald. "A Capital on the Potomac: A 1789 Broadside and Alexandria's Attempts to Capture the Cherished Prize." *Virginia Magazine of History and Biography* 89, no. 1 (January 1979).

Ward, Ruth M. "A Duel in Arlington." *Arlington Historical Magazine* 7, no. 1.

Weems, M.L. *God's Revenge Against Dueling.* Washington, D.C.: Gideon, 1820.

Whitson, Dorothy. "City Fire Spared Congressional Duel." *Alexandria Port Packet*, November 29, 1978.

About the Author

Michael Lee Pope is an award-winning journalist who lives in Old Town Alexandria. He has reported for the *Alexandria Gazette Packet*, WAMU 88.5 News, the *New York Daily News* and the *Tallahassee Democrat*. A native of Moultrie, Georgia, he grew up in Durham, North Carolina, and graduated from high school in Tampa, Florida. He has a master's degree in American Studies from Florida State University, and he lives in the Yates Gardens neighborhood with his lovely wife, Hope Nelson.

Visit us at

www.historypress.net